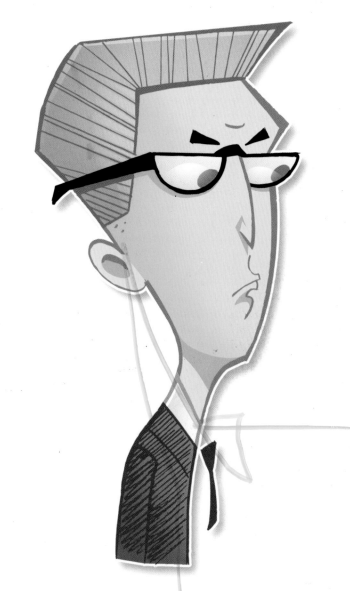

CARTOON ACADEMY

CARTOON FACES

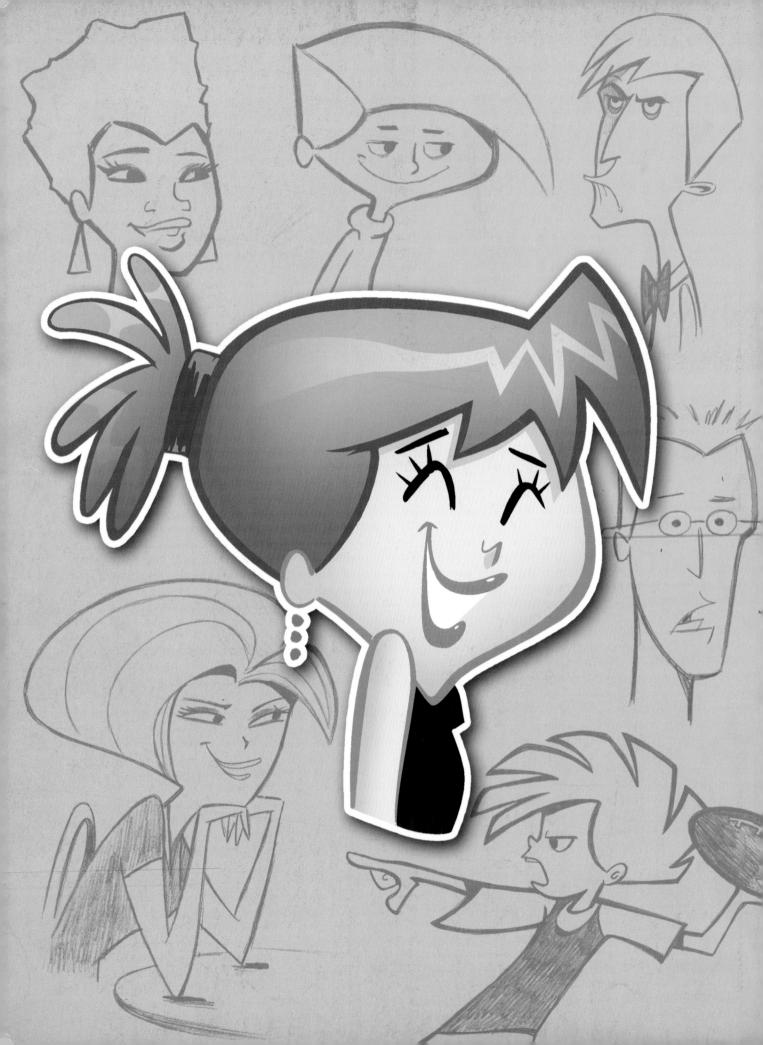

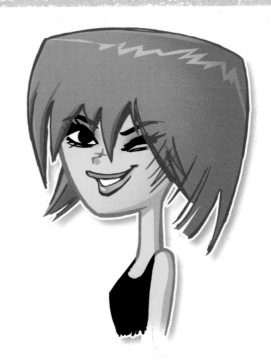

DRAWING WITH **Christopher Hart**

CARTOON ACADEMY

CARTOON FACES

How to Draw Heads, Features & Expressions

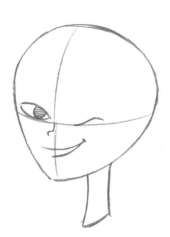

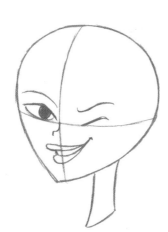

sixth&spring
books
NEW YORK

DRAWING WITH *Christopher Hart*

An imprint of Sixth&Spring Books
161 Avenue of the Americas, New York, NY 10013
sixthandspringbooks.com

Editorial Director
JOY AQUILINO

Art Director
DIANE LAMPHRON

Managing Editor
LAURA COOKE

Design, Digital Coloring &
 Production
STUDIO2PTO, LLC

Senior Editor
LISA SILVERMAN

Editorial Assistant
JOHANNA LEVY

Editor
JENNIFER SPIELVOGEL

Vice President
TRISHA MALCOLM

President
ART JOINNIDES

Publisher
CAROLINE KILMER

Chairman
JAY STEIN

Production Manager
DAVID JOINNIDES

Library of Congress Cataloging-in-Publication Data
Hart, Christopher, 1957-
Cartoon academy : cartoon faces : how to draw faces, features & expressions / Christopher Hart. — First Edition.
 pages cm
ISBN: 978-1-936096-74-9 (paperback)
1. Face in art—Juvenile literature. 2. Cartooning—Technique—Juvenile literature. I. Title.
NC1764.8.F33H37 2014
741.5'1—dc23

 2014017164

1 3 5 7 9 10 8 6 4 2

First Edition

This book is dedicated to all of my current, and future, Facebook fans. If you haven't already, come and join the fun!

www.facebook.com/LEARN.TO.DRAW.CARTOONS

–Chris

CONTENTS

INTRODUCTION

WHY FACES (AND ONLY FACES)

Every cartoon begins with the face. It establishes the character's age, type, role, and disposition. It is, by far, the most important ingredient for creating "character appeal"–that spark that makes cartoons engaging and memorable.

Funny facial features are essential, but they're not the full story. To create compelling, original characters, you also need tools that let you deviate from the classic head shape and rearrange the standard proportions of the face. All in the name of humor.

WHAT YOU'LL LEARN

This book is the complete resource for the aspiring, as well as the experienced, cartoonist. It includes an array of never-before-revealed techniques and tips.

You'll learn how to:

- Invent an endless variety of popular head shapes.
- "Squash" and "stretch" the head to make expressions even more dynamic.
- Draw a character at different angles, while maintaining a consistent look. (This is what aspiring artists struggle with the most.)
- Create and enhance hairstyles–they're a cartoonist's secret weapon.
- Experiment with shading, counterbalance, style, and a host of other important concepts.

PLUS PLENTY OF PRACTICE

Before you dive in, let me leave you with a last thought. The elements that go into creating an appealing character must be carefully integrated. However, that doesn't mean they should be woven together evenly. Humor comes from

contrast. For example, a large head shape with tiny features is funnier than a large head shape with large features.

This book is about creating humor with a few strokes of the pencil, and with the Drawing Exercises found at the end of the book, you'll have plenty of opportunities to put your skills to the test. I have every confidence that it will open up new vistas for your creativity.

YOUR HOW-TO-DRAW SHERPA

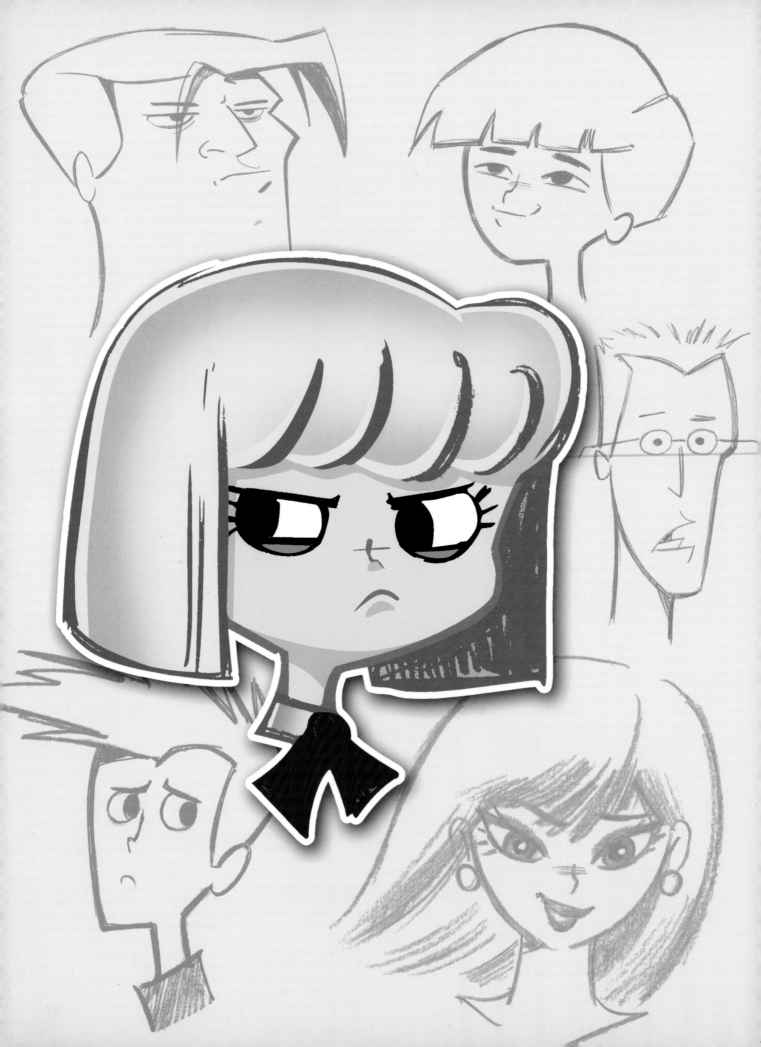

CARTOON HEAD BASICS

Drawing the head is like building a house: you need a good foundation, a plan, and a chimney. Perhaps not a perfect analogy, it nevertheless conveys an important point about drawing cartoons. I forget now what that point is, but that doesn't matter, because it's time to move on to our next concept, which is this: Beginning cartoonists often draw a face from start to finish in one fell swoop, starting with the features. But the professional artist first sketches the outline of the head, in order to establish a framework within which to work. This outline stage often gets short shrift from beginners. And that's too bad, because it actually deserves a lot of shrift.

On the following pages, I'll show you how to exaggerate various aspects of the head shape in order to maximize the appeal of your characters. The process of inventing eye-catching cartoon heads involves three key concepts:

1) Crafting the basic shape (outline) of the head
2) Creating amusing facial features (eyes, nose, mouth, and ears)
3) Choosing where to place the features in relationship to the various points along the head, in order to create a unique look (for example: a nose placed very high on the forehead)

THE CONVENTIONAL HEAD SHAPE

The conventional cartoon head is comprised of four elements: the upper head, the lower head, the neck, and the hair. It may surprise you to see "neck" and "hair" listed among the basic elements of the head. But everything is subject to exaggeration in cartooning, and therefore no area is left untouched.

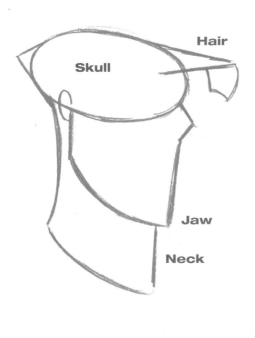

Hair

Skull

Jaw

Neck

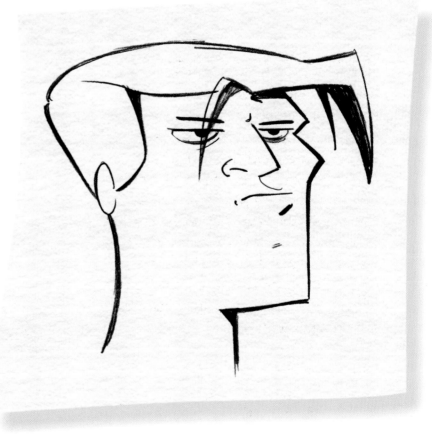

OUTLINE OF THE HEAD & THE CARTOON SKULL

To understand why the contours of the face are shaped as they are, we look to the simplified cartoon skull.

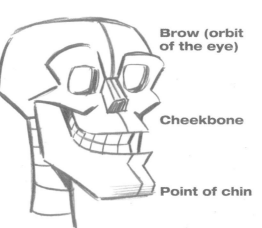

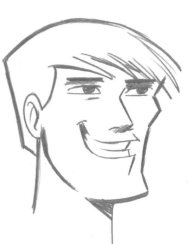

Brow (orbit of the eye)

Cheekbone

Point of chin

GUIDELINES

A big misconception aspiring artists have is that the guidelines are only for beginners. The aspiring artist, eager to shed the signs of being a novice, often jettisons the guidelines prematurely. Resist this impulse, as you would resist snickering at your boss's toupee. I recommend, instead, focusing on improving the effectiveness of guidelines in your work.

HEAD TILTS: UP & DOWN

When the head turns from one side to another, it's called an "angle." When the head moves up and down, it's called a "tilt." Adding a head tilt heightens the expression, as in this example of a man laughing. When the head tilts up, the features of the face shift up. Once again, we find that the Eye Line (the red line) is particularly useful as a guideline for drawing the head in different positions. When the head tilts down, the features are shifted lower.

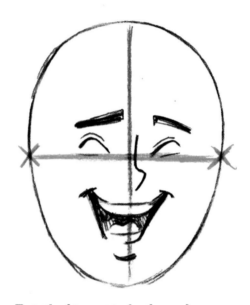

Front view, neutral angle
When there's no tilt, the Eye Line is drawn as a horizontal line

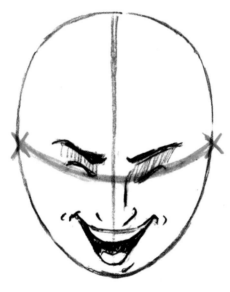

Front view, downward tilt
In a downward tilt, the Eye Line curves downward

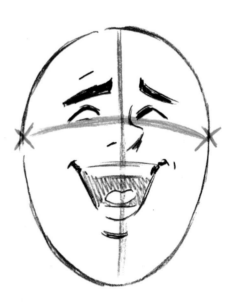

Front view, upward tilt
In an upward tilt, the Eye Line curves upward

EYES & THE TILT OF THE HEAD

When the head is facing forward, the eyes are at their roundest. When the head tilts up or down, the eyes appear to flatten out (become more oval), due to perspective.

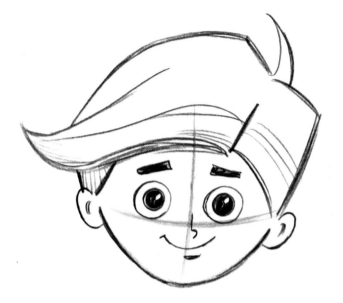

Front (eyes remain circular)

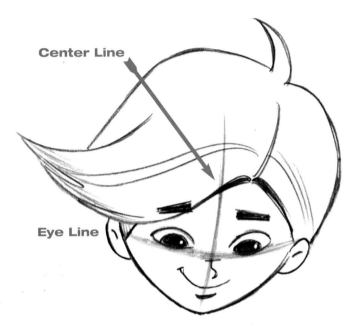

Center Line

Eye Line

Down (eyes flatten to ovals)

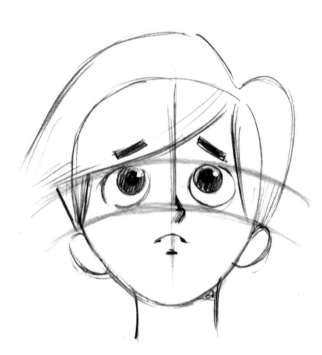

Sometimes the expression drives the shape of the eyes, such as with this "innocent" look.

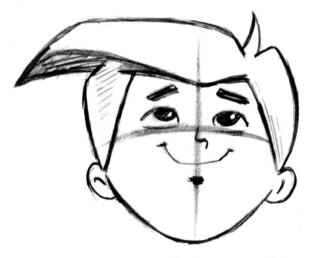

Up (eyes flatten to ovals)

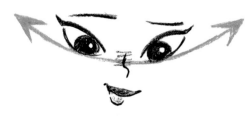

Downward curve

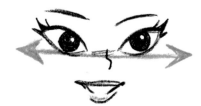

Neutral

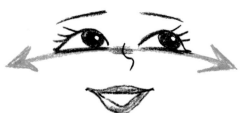

Upward curve

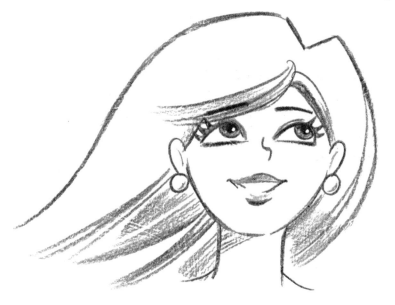

Head tilts up

Head in neutral position

Head tilts down

EYE CURVES

The direction of the curvature of the Eye Line creates the illusion that the character's head is tilting up or down. The curve can be subtle. But it's important nonetheless, and the eyes are drawn along that curve.

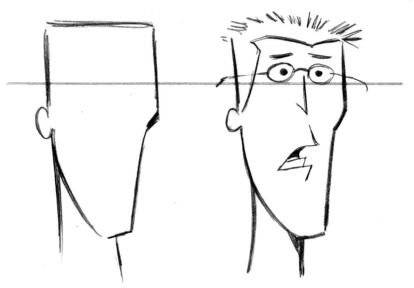

High Eye Line

HEIGHT OF THE EYE LINE

The height at which the Eye Line is drawn can change the look of a character. On this page, the same character has been drawn three different ways. Each time, the Eye Line appears at a different height along the head, and therefore, the features of the face are gathered in a different spot, which changes the look. This gives you another tool to use in creating characters.

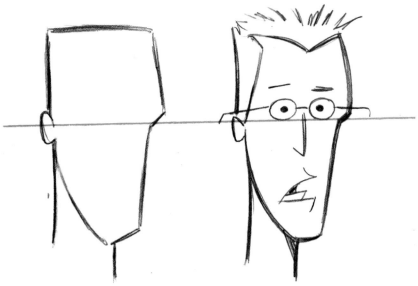

Centered Eye Line

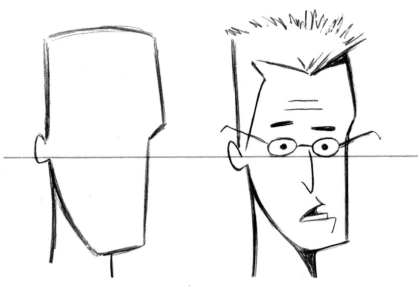

Low Eye Line

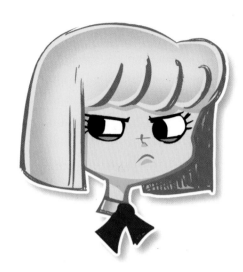

YOUNG GIRL
Large eyes, a small nose, and a small mouth. Hairstyle is round and bouncy.

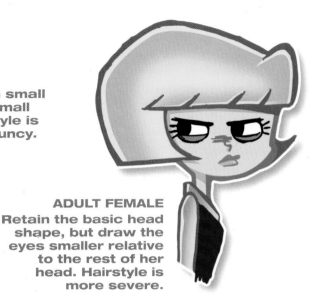

ADULT FEMALE
Retain the basic head shape, but draw the eyes smaller relative to the rest of her head. Hairstyle is more severe.

CHANGING THE AGE OF YOUR CHARACTER

How do you make a character look younger? One way is to adjust the size and shape of the features. You can also adjust the relative distance between the features, such as drawing the mouth very close to the nose. Sometimes a combination of both methods works best.

YOUNG BOY
Features low on the face. Large foreheads and small chins. Hair is uncombed.

TEEN BOY
Features in the middle of the face, not toward the bottom, so chin looks larger. Hair is still uncombed. He's a boy, what did you expect?

DRAWING THE FEATURES

Up to this point, we've been covering the basic shapes of the cartoon head. Now we'll begin to craft the features of the face, which will bring your characters to life. Certain features work well on certain characters, but not on others. For example, "innocent" characters work best with large eyes, but villains work best with small, beady, or slender eyes.

Can you ever break these rules? Yes, but not without a signed note from me. By changing and combining different features of the face, you can create tons of different characters.

THE EYES

Many beginners work hard to capture the basic shape of the eyeball (a circle, for example), but overlook the rest of its components. I want you to think about four aspects of the eye: the pupil, the eyeball, the eyelid, and the whites. By giving some creative effort to each element, you'll develop more engaging cartoon characters.

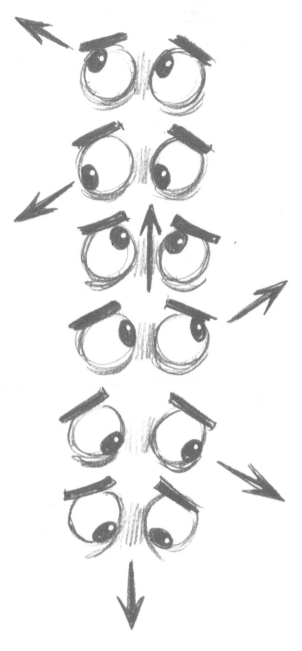

Glance: page left

Glance: page right

EYE DIRECTION

While the side glance is a funny look, you can squeeze out even more expression if you add an "up" or "down" angle. Look at the sampling of eye positions above. Notice how kooky the eyes look simply by adding an up or down angle.

"STARING" VERSUS "LOOKING"

"Staring" indicates a type of droll, mindless gaze. "Looking" is a sharper, more directed action. Both are funny. Staring puts the focus on the character's state of mind; looking puts it on the thing that has caught his eye. Little touches like these are important. Will the sky fall if you don't use them? Probably not, but why take the chance?

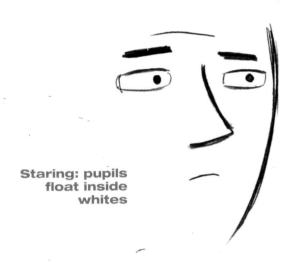

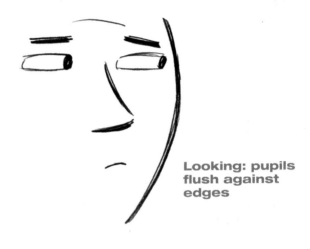

Staring: pupils float inside whites

Looking: pupils flush against edges

RUBBERY EYES

The cartoon eye is flexible, just like the mouth. When the mouth makes an expression-a scowl, for example- the eyes generally change shape in response. This adds a double whammy. For example, a frown causes the eyes to narrow. Remember, the eyes can get bigger or smaller, stretch or squash.

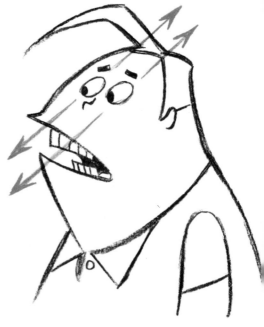

Both eyes usually tilt on the same axis.

Normal eye shape

Devious expression: narrow eyes

Eyes can change shape based on the expression.

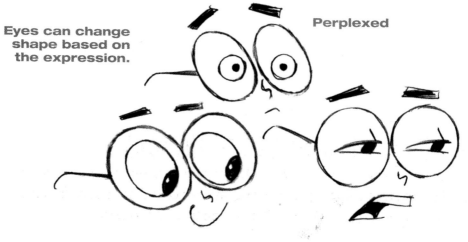

Perplexed

Cheerful

Indifferent

NORMAL EYE POSITION
Bridge of the nose goes between the eyes.

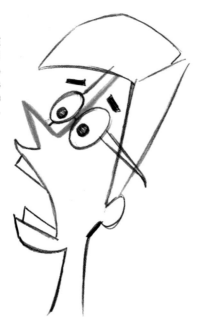

WACKY

GOOFY EYES
Bridge doubles as outline of the face.

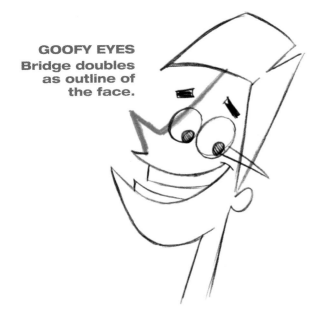

WACKIER

TWO EYES ON THE SAME SIDE OF THE HEAD

Every human has one eye on either side of the face—except in cartooning. A goofy look is created when both eyes appear on the same side of the head. To achieve this look, draw the eyes close together, and then shift the position of the nose.

Crying

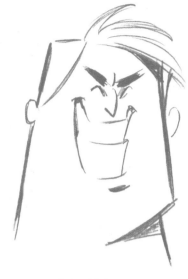

Laughing

CLOSED-EYE EXPRESSIONS

Closed-eye expressions are drawn with the eyes either curving up or curving down, depending on the attitude you wish to express. Closed-eye expressions are funny, and great for pacing (they add variety to a character's menu of standard expressions). But you have to rely even more on the eyebrows and mouth to tell the story.

Smug smile (open)

Smug smile (closed)

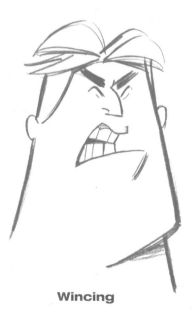

Wincing

Dismissive

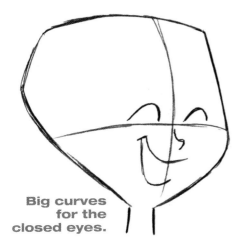

Big curves for the closed eyes.

THE FAMOUS CLOSED-EYE LAUGH

The laugh is, by far, the most popular closed-eye expression in cartoons. Her small open-mouth smile indicates a chuckle, while a wide one would indicate a guffaw. Note how the eyelashes perk upward and the eyebrows are high on the forehead and tilted up.

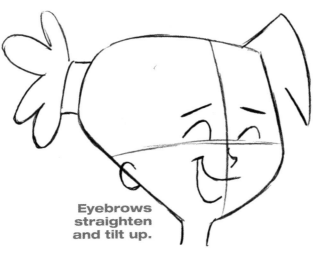

Eyebrows straighten and tilt up.

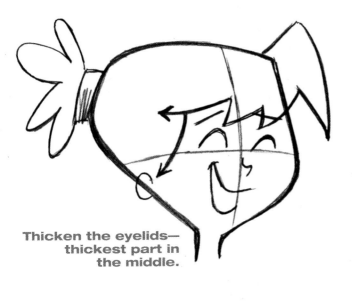

Thicken the eyelids—thickest part in the middle.

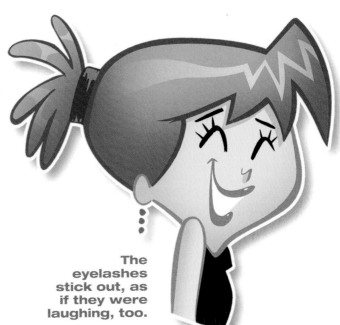

The eyelashes stick out, as if they were laughing, too.

FEMALE EYES

What makes one pair of female eyes so appealing, and another pair just ho-hum? Guess. No, really, guess:

a) The color
b) The expression
c) A scar or eye patch

You were so close: the correct answer is "d) The whites of the eyes." The more white you show in a female eye, the cuter and perkier it will appear. For a sultry look, draw heavy eyelids.

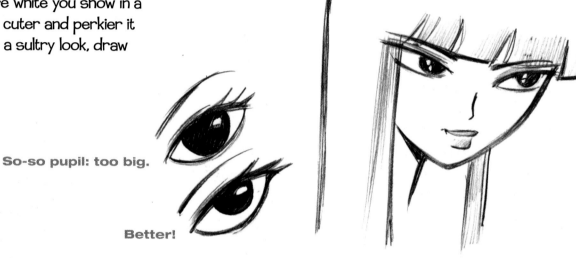

So-so pupil: too big.

Better!

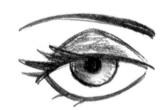

Cover top of eyeball with the lid for a sultry look.

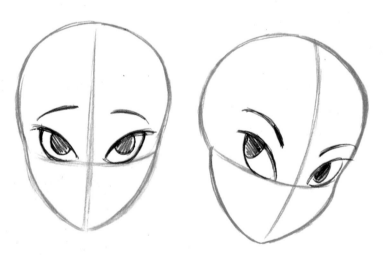

In each pose, take care to leave plenty of space around the pupils. More "whites" show in a side glance than in a straightforward look.

EYEBROWS

Eyebrows are the unsung heroes of cartoon expressions. They are more than mere lines drawn above the eyes. They are a force in motion. They have thrust, as indicated by the directional arrows in the examples on this page. The eyebrows often work together as a unit, meaning that if one eyebrow is angled downward in a frown, the other will also angle downward. But you can also create wacky expressions with asymmetrical eyebrows.

Anger

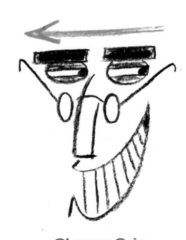

Cheesy Grin

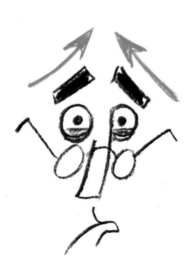

Disapointment

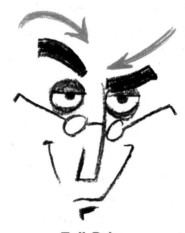

Evil Grin

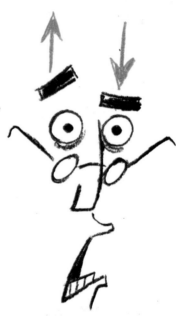

Astonishment

Confusion

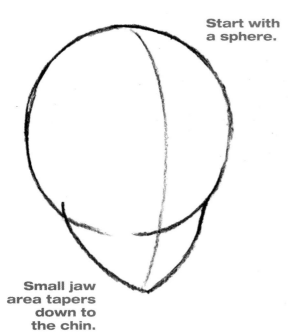

Start with a sphere.

Small jaw area tapers down to the chin.

FEMALE EYEBROWS

Female eyebrows are typically thin, long, and arched. The roundness of the eyebrows emphasizes the roundness of the forehead.

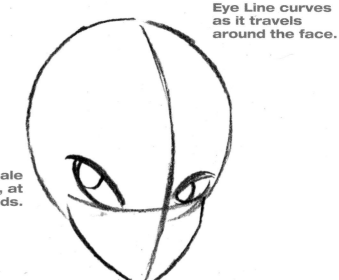

Eye Line curves as it travels around the face.

Tilt female eyes up, at the ends.

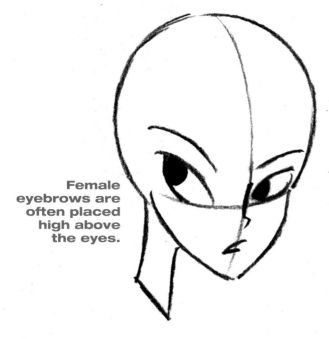

Female eyebrows are often placed high above the eyes.

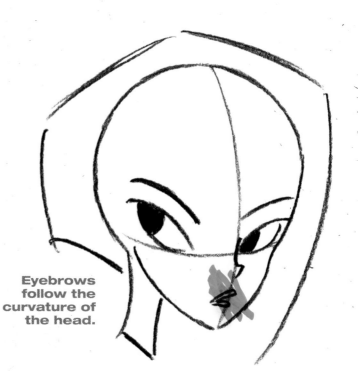

Eyebrows follow the curvature of the head.

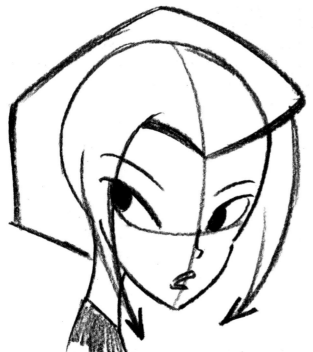

Underscore the three-dimensional look with exaggerated hair that curves around the head, framing it.

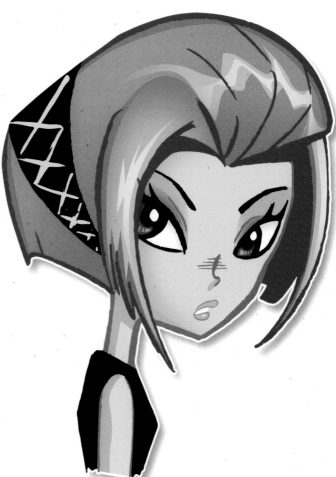

In the 3/4 view, almond-shaped eyes spaced apart show perspective. The far eye appears somewhat narrower and closer to the bridge of the nose.

EYES & BROWS: PUTTING THE CONCEPTS TO WORK

Let's take a few characters, each with a different style of eyes, and practice drawing them step by step. As you "build" the character, notice how the eye type reflects the personality type. It's not unusual to need a few tries to get the eyes just how you want them. Therefore, work sketchy and light at first, so you can erase if you need to. (Everyone needs to!)

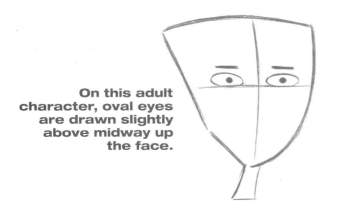

On this adult character, oval eyes are drawn slightly above midway up the face.

OFFICE MANAGER (OVAL EYES)

Since an office manager is the go-to guy for all the problems that come up, I think it's funny to make him utterly and completely clueless.

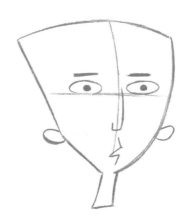

A small mouth works well with meek character types.

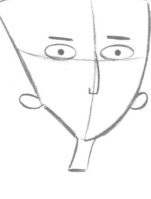

Thin, straight eyebrows create a funny contrast. Low ears can be used on dorky characters of any age.

Draw a short diagonal line for the back of the head, so the hair doesn't come to a point.

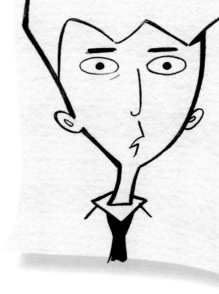

The eyes tell it all: he's in over his head—before the day has even begun.

THE "CUTE KID" TYPE (CIRCLE EYES)

Kid characters are generally high-energy, with bouncy personalities. It's not until high school that their zest for life is destroyed by five hours of homework each night. Eager eyes are drawn as circles, with pupils floating in the middle.

Now, a word about glasses: on younger characters, glasses generally look funnier oversized. By and large, it's the adults who get the smaller glasses.

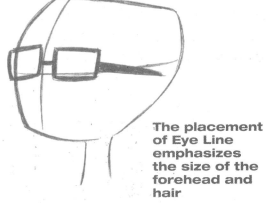

3/4 view and large, square glasses

The placement of Eye Line emphasizes the size of the forehead and hair

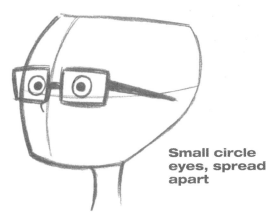

Small circle eyes, spread apart

An impossibly skinny neck attached to a big head

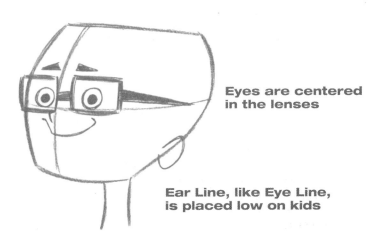

Eyes are centered in the lenses

Ear Line, like Eye Line, is placed low on kids

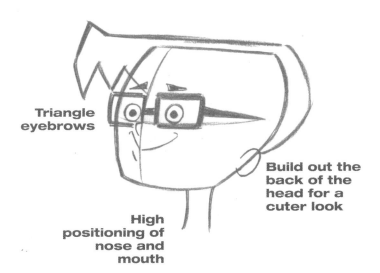

Triangle eyebrows

High positioning of nose and mouth

Build out the back of the head for a cuter look

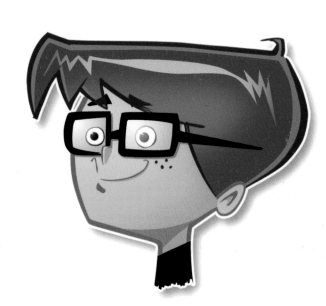

Erase the outline of the face, which had appeared inside of the far lens.

ELF GIRL (MAGICAL EYES)

Elves, fairies, and an assortment of enchanting characters are famous for their slender, tilted eyes. This little elfin girl is a good example. Notice the severe eye tilt, which immediately puts her in the fantasy realm.

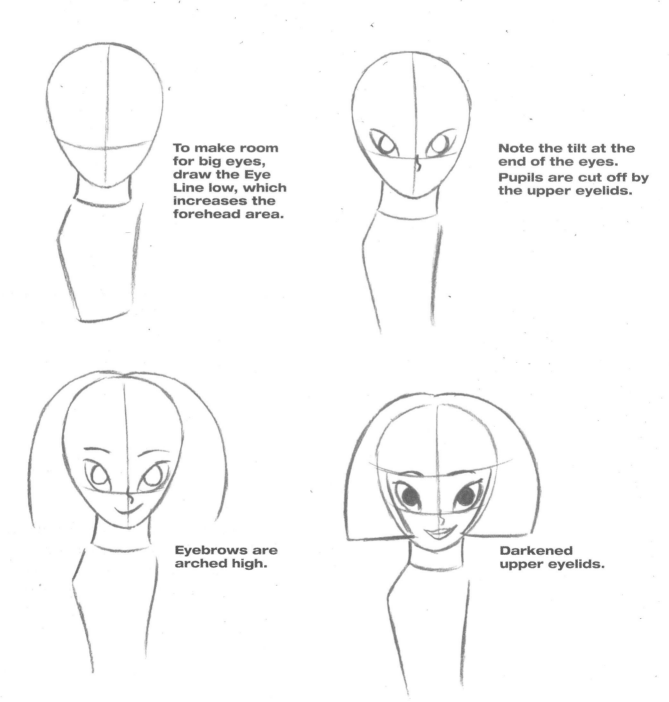

To make room for big eyes, draw the Eye Line low, which increases the forehead area.

Note the tilt at the end of the eyes. Pupils are cut off by the upper eyelids.

Eyebrows are arched high.

Darkened upper eyelids.

Bring the hair around the face, to accentuate its roundness.

Blend the pupils into the line of the upper eyelids.

Two big shines in the eyes add sparkle to the smile.

Elves can be cute, hence the big eyes. But they can also be mischievous, which would mean narrow eyes. Some are sleepy, which means droopy eyes. The type of eyes helps define the type of character.

THE NOSE

Not too many people give noses a lot of thought. I do, partly because, well, what else am I going to do? I don't like to watch sports. I hate the theater and being outside in nature. Thinking about noses is the highlight of my day. Boy, I need a vacation.

You can create a practically unlimited variety of nose types by adjusting the length and width. In fact, if you were to count all the grains of sand on a beach, you might even still have more cartoon nose types. My point is that you should not restrict yourself to drawing a quasi-realistic nose. Cartoon noses can be round, pointy, droopy, upturned, bent, sloping, etc. While the eyes are great conveyers of expression, the nose is often used to reflect personality type. For example, a haughty woman may have flared nostrils, while a sinister character will have a sharp nose.

THE STANDARD NOSE TYPE

I've introduced this diagram of a semi-realistic nose to show you the components of this most prominent feature of the face. Most cartoon characters, however, omit details such as the covers of the nostrils, and rarely shade the "sides" of the bridge. Notice how cartoonists simplify the look of the nose to create stylish variations.

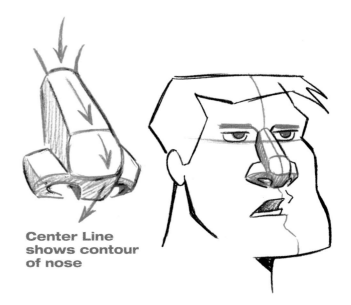

Center Line shows contour of nose

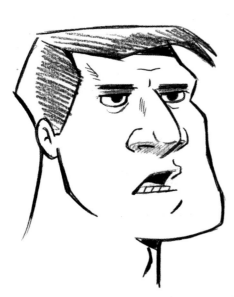

SEMI-REALISTIC NOSE
Too much definiton

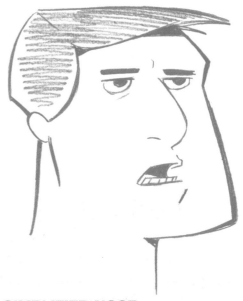

SIMPLIFIED NOSE
Blend the details to create a simpler overall impression

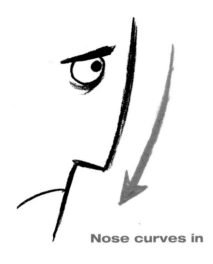

Nose curves in

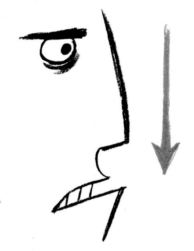

Nose is vertical

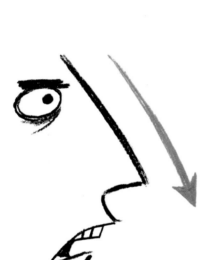

Nose slopes out

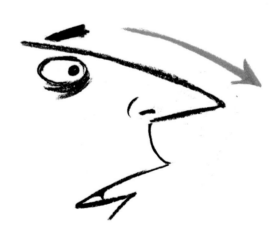

Nose is horizontal

THE DIRECTION OF THE NOSE

The nose can be drawn vertically, diagonally, or horizontally. It can originate from a point between the eyes or extend directly from the forehead to create a single, long line. The nose is a bellwether for the character: if it is highly exaggerated, then generally, the look of the character will be, too.

CREATING NOSES IN PROFILES

It is easiest to invent a nose type when your character is positioned in a profile. The profile forces you to consider not only the length of the nose, but the angle at which it protrudes from the forehead. To see how it works, let's match some popular personality types with specific nose types drawn at different angles.

UPTURNED NOSE
Great for kids, teens, and pretty females.

BENT NOSE
Used on males and rugged types.

The bridge of the nose is curved when the tip is upturned.

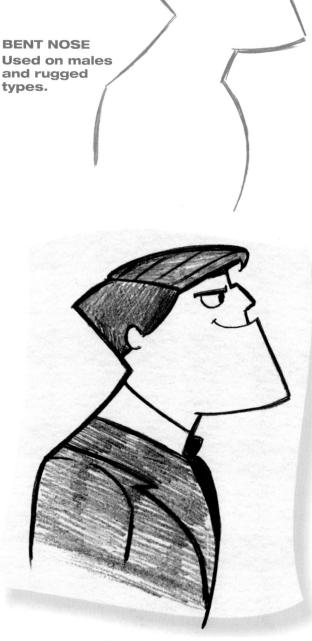

Bent, rugged noses are usually short.

LOCKING THE NOSE INTO POSITION

The nose is at the center of the cluster of facial features, which include the eyes and the mouth. The nose acts as a marker that helps keep the other features in their correct positions. But how do you find the correct position for the nose itself?

While there are no "rules" in art-except the one about not touching the paintings at the Louvre-there are generally accepted guidelines. One tells us that the bridge of the nose begins where the Eye Line and the Center Line cross. Placing the bridge at a specific point on the face enables us to turn the head at various angles while maintaining the relationship among the features.

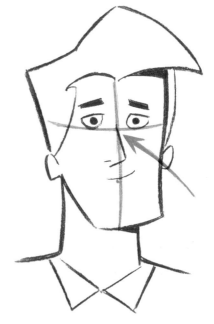

Bridge of the nose originates at the point where the Eye Line and Center Line cross—just between the eyes.

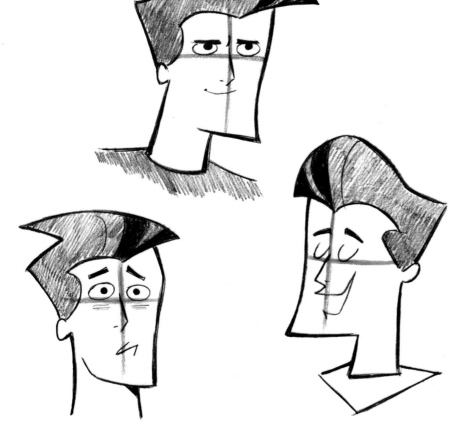

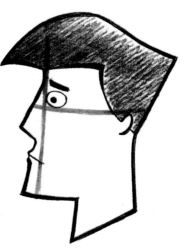

No matter which direction the head turns, no matter the expression, the bridge of the nose remains fixed: an organizing principle to hold the other features in place.

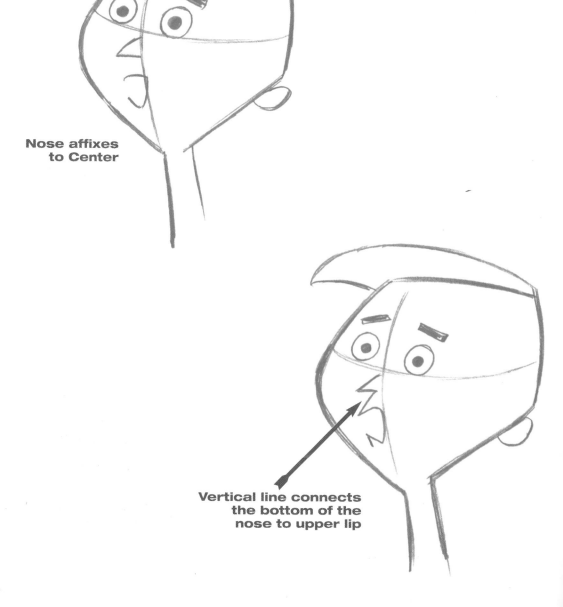

ELIMINATE THE BRIDGE

Let's live on the wild side. Let's see what happens when we eliminate the bridge of the nose altogether. This results in a zany look where the nose appears to be floating in the middle of the face. I find this approach to be particularly effective on flummoxed character types.

Center Line

Nose affixes to Center

Vertical line connects the bottom of the nose to upper lip

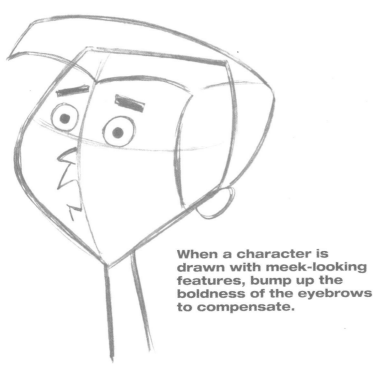

When a character is
drawn with meek-looking
features, bump up the
boldness of the eyebrows
to compensate.

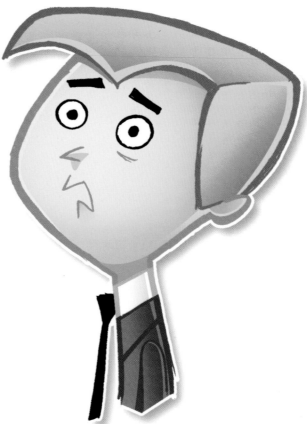

This guy reminds me of a substitute teacher
I once had. Note the clueless expression.

NOSES: PUTTING THE CONCEPTS TO WORK

Now, let's take what we've learned about noses and apply it to some unique cartoon characters.

Foreheads are usually small on rugged characters.

VIKING (RUGGED NOSE)

Like many rugged character types, the Viking has a short, bent nose. We also give him a long upper lip to make room for that thick, bushy mustache.

Many rugged noses are also short.

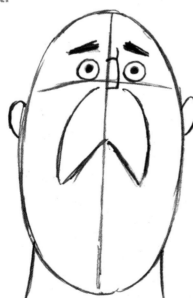

That's a lot of jaw: to make use of the space, draw a thick mustache.

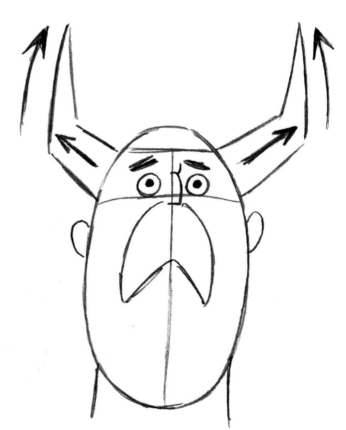

I like to draw horns with a kooky angle, to keep it cartoony.

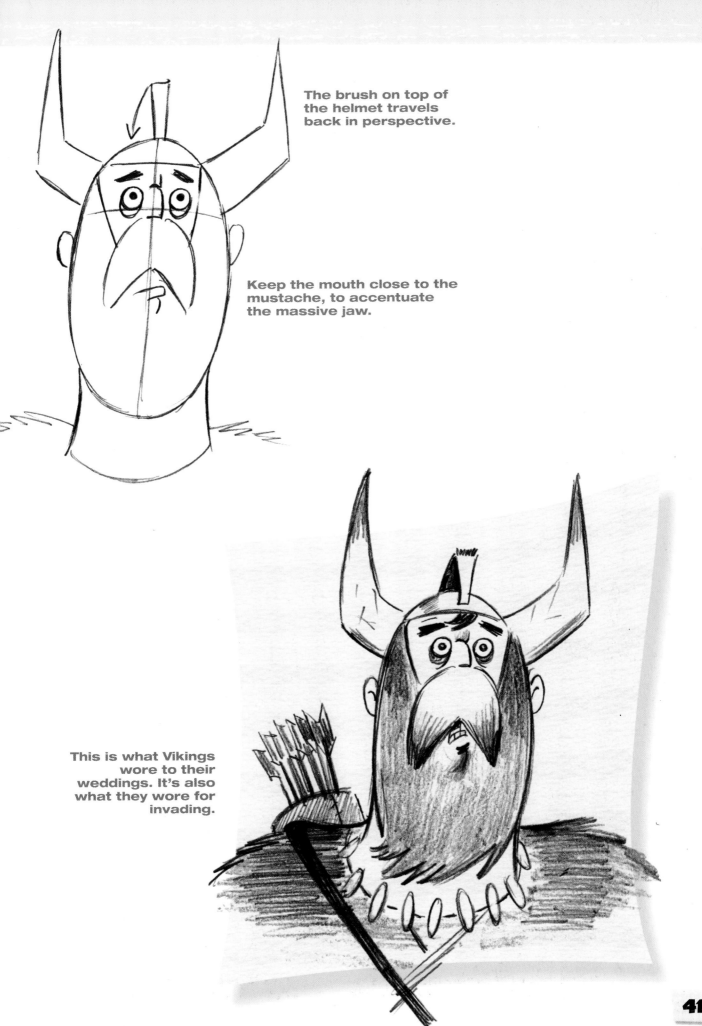

The brush on top of the helmet travels back in perspective.

Keep the mouth close to the mustache, to accentuate the massive jaw.

This is what Vikings wore to their weddings. It's also what they wore for invading.

41

BUSINESSMAN

The nostrils bookend the ball of the nose. You don't have to actually attach the nostril covers to the main part of the nose: the viewer will subconsciously connect them for you.

Basic head outline, with a flat top.

Add variety by bumping out the brow of the forehead a notch.

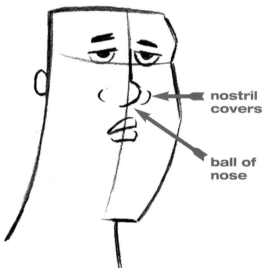

nostril covers

ball of nose

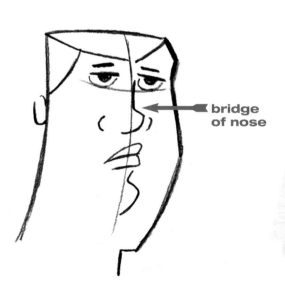

bridge of nose

I like the comical look of using little circles to indicate the nostrils.

THE MOUTH

Although the mouth is very important, we often take it for granted. Jack Handey, who is a friend and the best-selling author of the humor book series "Deep Thoughts," once wrote, "The face of a child can say a lot. Especially the mouth part of the face."

As we ponder the meaning of that quote, let's continue. The male mouth is just a horizontal line. But female lips are not always so simple. Each lip has thickness and shape, and often the upper and lower lip fit together with an overbite.

Basic model: a simple thin line for the upper lip, and a short shadow below bottom lip

Slightly wackier: a short line that connects the bottom of the nose to upper lip

FEMALE MOUTH

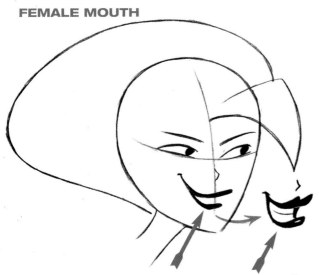

Upper lip without cupid's bow

Upper lip with cupid's bow

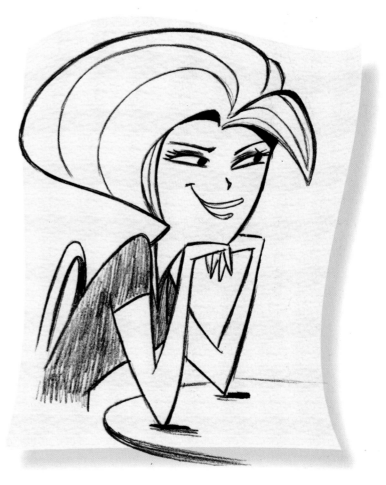

"Tell me all the dirt!"

43

THE SIMPLIFIED MOUTH

Minimalism is funny. A simple mouth, drawn with an economy of line, can be more amusing than a detailed version. Detail can suck the humor right out of a picture. If you don't believe me, look at the painting of the Mona Lisa. Everything is filled with detail. Detail here, detail there. And not one thing to laugh at! After 5 minutes, you would kill just to hear a knock-knock joke.

SMILE
A simple curved line rises high on the face

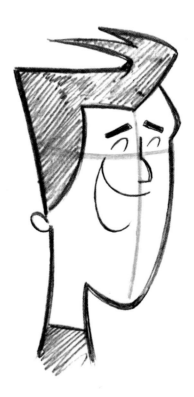

LAUGH
Interior of the mouth doesn't need to be defined

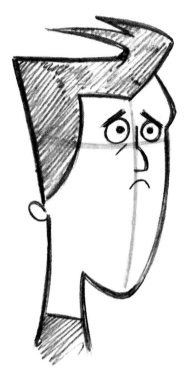

DISAPPOINTMENT
A petite, downward curve,
centered under the nose

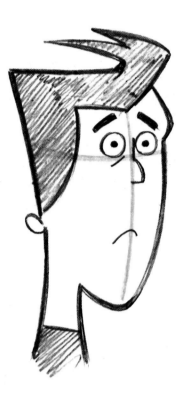

SURPRISE
Mouth drops low on the face

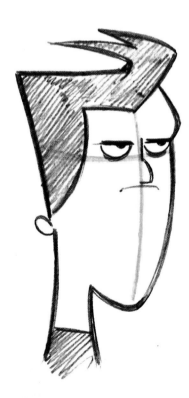

FROWN
Flattened mouth, super close
to the bottom of the nose

THE SIMPLIFIED SMILE: STEP BY STEP

Here's a smile that's easy to do and very popular. It's drawn in a fun, minimalistic style. This smile is most expressive when the mouth is opened. You can add the teeth, tongue, and hollow of the throat, but I prefer to simplify this mouth type by eliminating those aspects to keep it uncluttered.

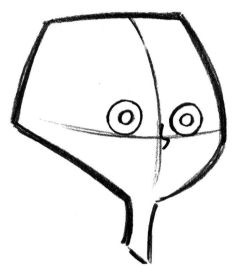

The pupils are floating in the middle of the eyeballs. The nose is small and upturned.

Start with a wide head on a thin neck.

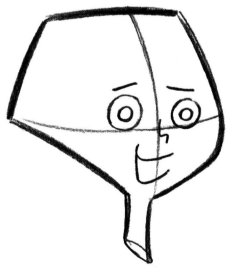

Two goofy lines map out the lips. Curl the edge of the smile upward, into the area of the cheek.

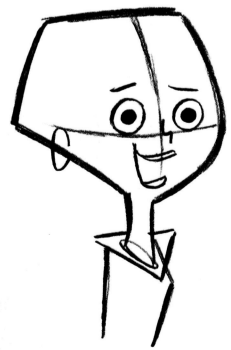

Add thickness to the tapered lips.

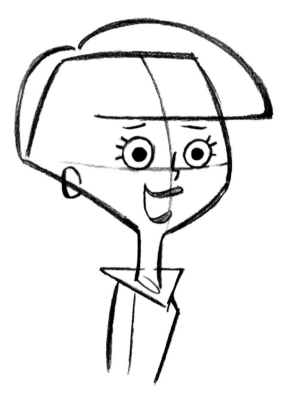

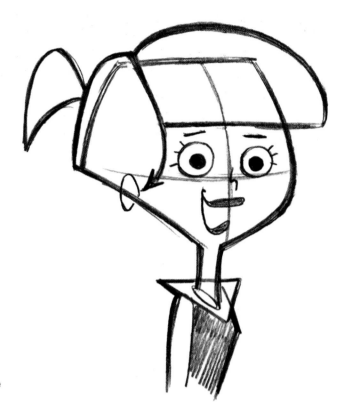

The classic retro smile is petite, because it contrasts with an oversized head.

Note how the stiff eyelashes radiate like spokes on a wheel. This gives the perkiness extra voltage.

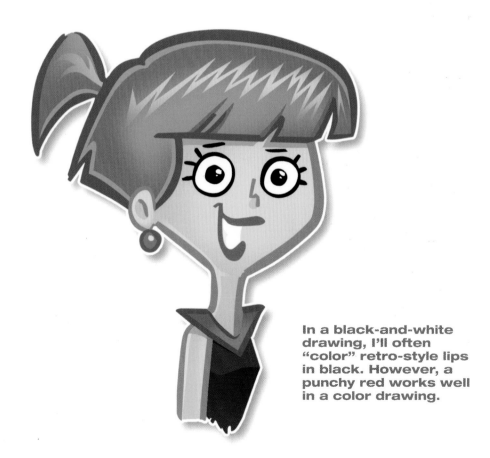

In a black-and-white drawing, I'll often "color" retro-style lips in black. However, a punchy red works well in a color drawing.

STYLISH LIPS

Full, curvy lips are great for chic-looking characters. In a black-and-white drawing, white or only partially shaded lips give the impression of a light color lipstick, instead of the traditional deep red. You can also go with any number of colors for the lips, even including purple or lime green. The only color I have never seen used on lips is "puce." Just be sure the lip outline is a different color from the lipstick, or the two will blur.

Big, almond-shaped eyes require a wide head shape, such as an oval.

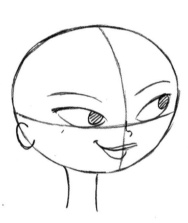

Note the overbite.

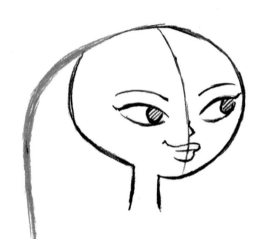

Add a lot of back-head area with hair.

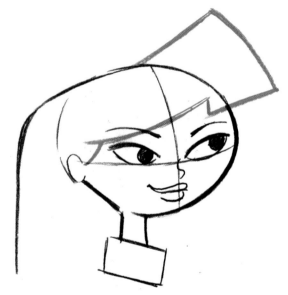

An up-tilt to the bangs gives the character extra punch.

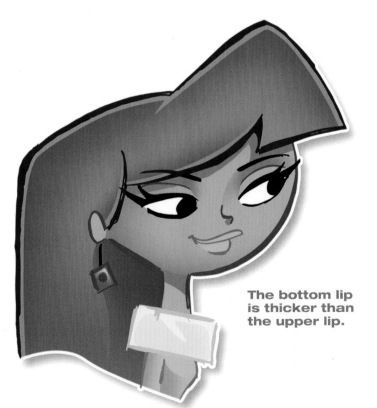

The bottom lip is thicker than the upper lip.

DRAWING TEETH WITH DIMENSION

Drawing the bottom set of teeth in perspective can be a fun addition to your repertoire. The bottom set of teeth is drawn with a wrap-around line, shown in red on the two examples. It requires more detail for the overall mouth, and therefore is not a good fit for very simplified characters.

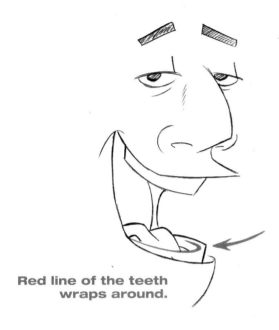

Red line of the teeth wraps around.

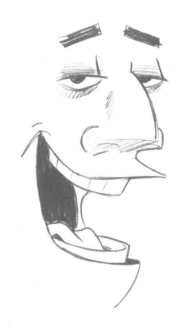

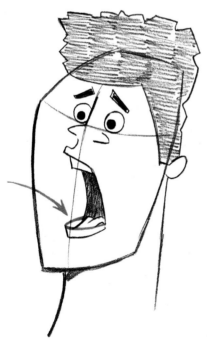

Drawing teeth in perspective makes the character more complex.

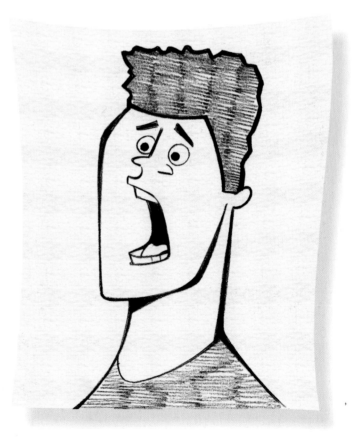

THE EARS

The ear is given short shrift in many drawing books. But not in this book. Why? Is it because the ears are the most eye-catching feature of the face? Ha, ha! No. The ears are, however, excellent for adding humor and style. Cartoon ears are funny because they're usually drawn unrealistically, in the wrong proportion (too small), and in the wrong position (too low). So draw them wrong—and be proud! Your cartoons will thank you.

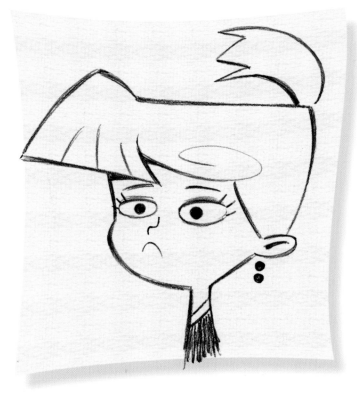

In either direction, up or down, cartoon ears are often drawn sticking out, past the outline of the back of the head.

Vertical ear direction

Horizontal ear direction

EARS UP & DOWN

Round ears have no direction up, down, or sideways. They're circles. To add style, stretch the ear into either a horizontal or a vertical shape. Every aspect of a character is an opportunity to add humor. The difference between a professional cartoonist and a beginner is that the professional looks to capitalize on every component of his drawing.

EAR TILT

The ear has a natural tilt to it. This can be seen in both the front view and the 3/4 view. We can visualize cartoon ears as disks-like little saucers-that are attached to the head. But without teensy cups to go with them.

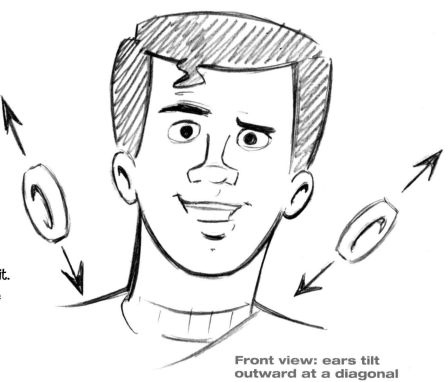

Front view: ears tilt outward at a diagonal

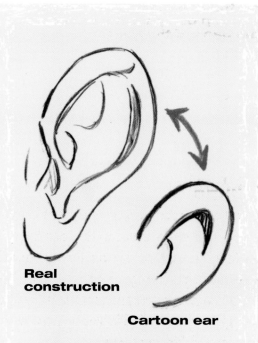

Real construction

Cartoon ear

Note the extreme simplification of the cartoon ear compared with the real ear.

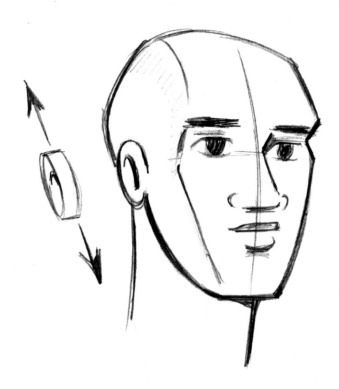

3/4 view: ear tilts at a diagonal

Center Line

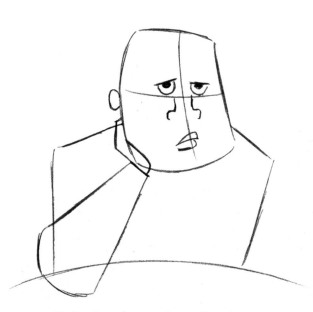

In a 3/4 view, the Center Line is shifted to the right.

EARS IN THE 3/4 VIEW

In the front view, both the left and right ears are visible. In the profile, only one ear is visible. But what about in the 3/4 view? Of course, there are times when you can exaggerate anything to great effect. But in most cases, the far ear on a 3/4 view is hidden from view. When you add the far ear, it gives the effect of flattening the face. For a look with more depth, eliminate the far ear in the 3/4 view.

The Eye Line is drawn the same way in the front view and the 3/4 view.

Palm heel overlaps the jaw.

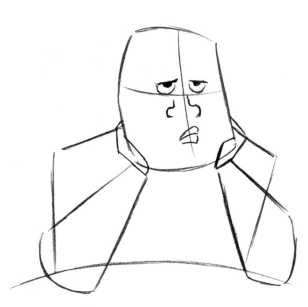

Elbows out, shoulders in.

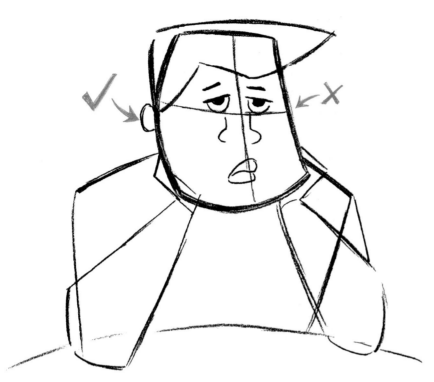

Turning the head to the right eliminates the right ear from view.

A real person's ear is drawn inside the outline of the head. But cartoon ears can stick out past the outline. I imagine that this character is sitting through a boring college lecture. I believe the study of sociology was invented as a form of torture.

EARS: PUTTING THE CONCEPTS TO WORK

Here's our next stab at drawing a full cartoon face. Remember: the more unrealistic the ears, the better. Most newbies believe that in order to create something funny, it has to be big. But big ears are old-fashioned. Better to draw them small and goofy.

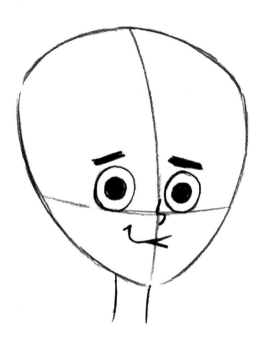

BOY WITH GOOFY EARS

Here's an affable type. He's got a pleasing look, with no outstanding features, except the quirky ears. "Quirky" is a good thing in cartoons. Not so good for used cars.

Features are usually mushed together, rather than drawn out. This is especially true for young or cute characters.

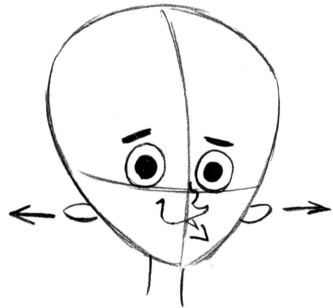

Keep ears on the same level as each other. Add funny lower lip.

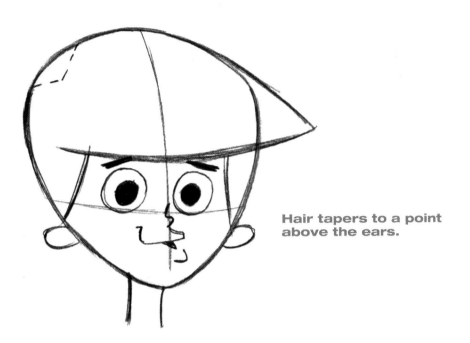

Hair tapers to a point
above the ears.

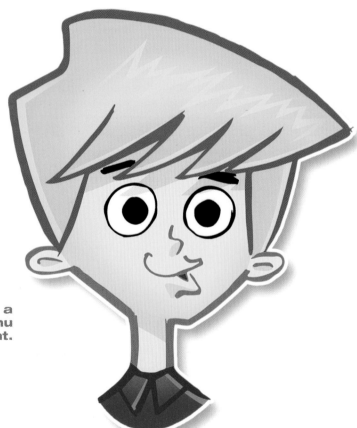

His expression on seeing a
165-ounce soda on the menu
of a fast-food restaurant.

The ears are the goofiest
feature on this character.

THE NECK

Why include the neck in a book about drawing the cartoon face? Think of the neck as a pedestal, holding a bowl of fruit. Wait. Try this instead: picture the neck as a Greek column, and on top of that column is a bowl of fruit. Okay, forget the fruit. I'll keep working on it, but for now, let's go with: cartoon necks are funny.

Straight lines emphasize a character's flat look.

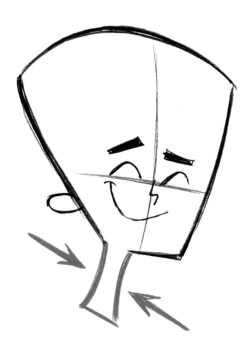

Softer, curved lines emphasize a lifelike quality; tapering creates a smoother line flow where the head attaches to the neck.

Curved and tapered.

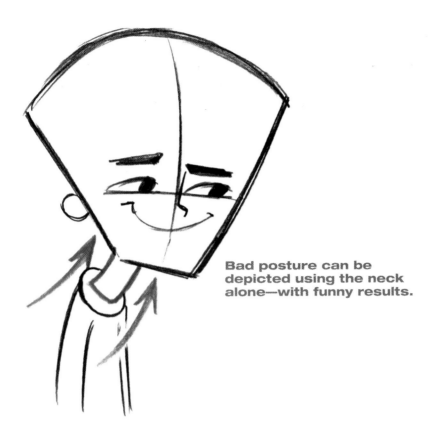

Bad posture can be depicted using the neck alone—with funny results.

The cartoon neck is often blended into the basic character design of the head. For example, the neck on a weak character may replace the chin. By contrast, a sturdy character may have such a wide neck that his head appears subsumed by it. There's also the practical consideration: without the neck, a head looks disembodied. Your viewers expect to see the neck, even in a close-up.

This character is similar to the boy at left, except for bad posture, indicated by the neck.

THE NECK & THE TILT OF THE HEAD

Cartoon necks can be burly for rugged and athletic characters, but most often, they're skinny. A spindly neck gives the head the funny appearance of a ball balancing on a pencil. Skinny necks also help bring attention to head tilt.

There are four basic head tilts: forward, back, up, and down. However, there is an unlimited amount of looks you can create based on the degree of the tilt.

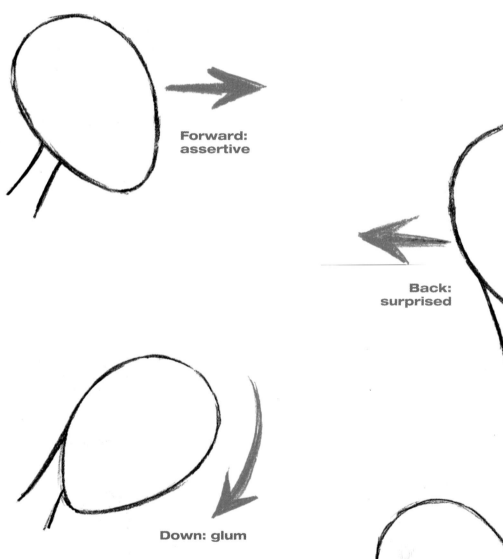

Forward: assertive

Back: surprised

Down: glum

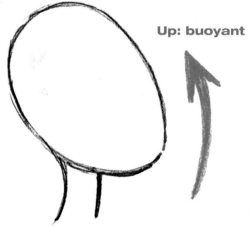

Up: buoyant

DEFINE THE LOOK

We want to be rather definite about how we draw the outline of the face. For example, we can make it a straight line, or a line that becomes jagged at the cheekbone, or a line with a protrusion at the brow of the forehead. By focusing on the shape of the face, we can define the character's look.

TEENAGE GIRL
Soft cheekbone
halfway up the head

MUSIC TEACHER
Forehead brow prominence

PROMINENCES

A "prominence" is a fancy way of saying "something that stands out." The most common prominence used to add variety to the shape of the face is the cheekbone, followed by the forehead brow and the chin.

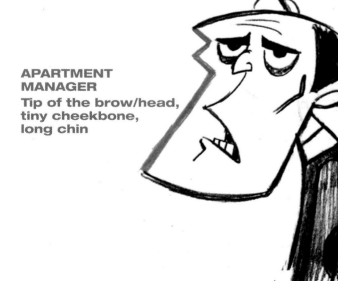

APARTMENT MANAGER
Tip of the brow/head,
tiny cheekbone,
long chin

HOTHEAD GUY
High brow, long jaw

DEFINING THE FRONT OF THE FACE: STEP BY STEP

Now that we've become familiar with the concept of creating a unique look for the Line of the Face, we'll apply it step by step to character creation. Because cartoons are built on more than one concept, I'll point out a variety of different tips along the way. Although these steps have been illustrated in two colors, I recommend that you work with a regular pencil or an art pencil. The art pencil grades I prefer for rough sketching are HB, B, or F.

GLAMOUR CHARACTER

This character has a round head, which lends itself to a curved line as the front of the face. But we want to make it a little more interesting than that, so we'll also square off the back of the head. This makes the head look bigger, which is a funny look on a slender, female character.

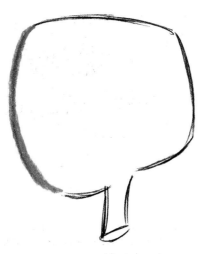

The front of the face is a rounded line that travels from the top of the head to the bottom of the chin.

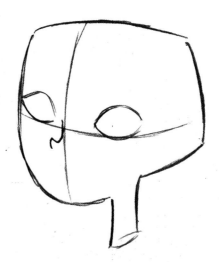

Note how we add size (width) by building out the back of the head.

Round off the chin.

Heavy eyelashes: a '60s "mod" look, which is good for retro cartoons.

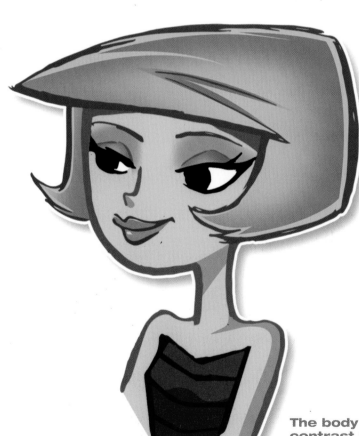

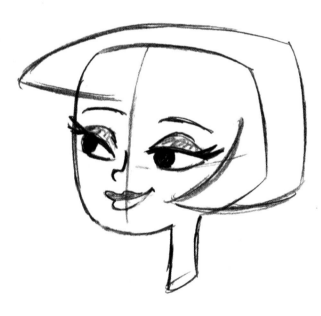

Lips are drawn at a 3/4 view, just like the overall direction of the head.

The popular "bob" haircut curls up to a point.

The body is slight, which creates contrast with the oversized head: popular retro proportions.

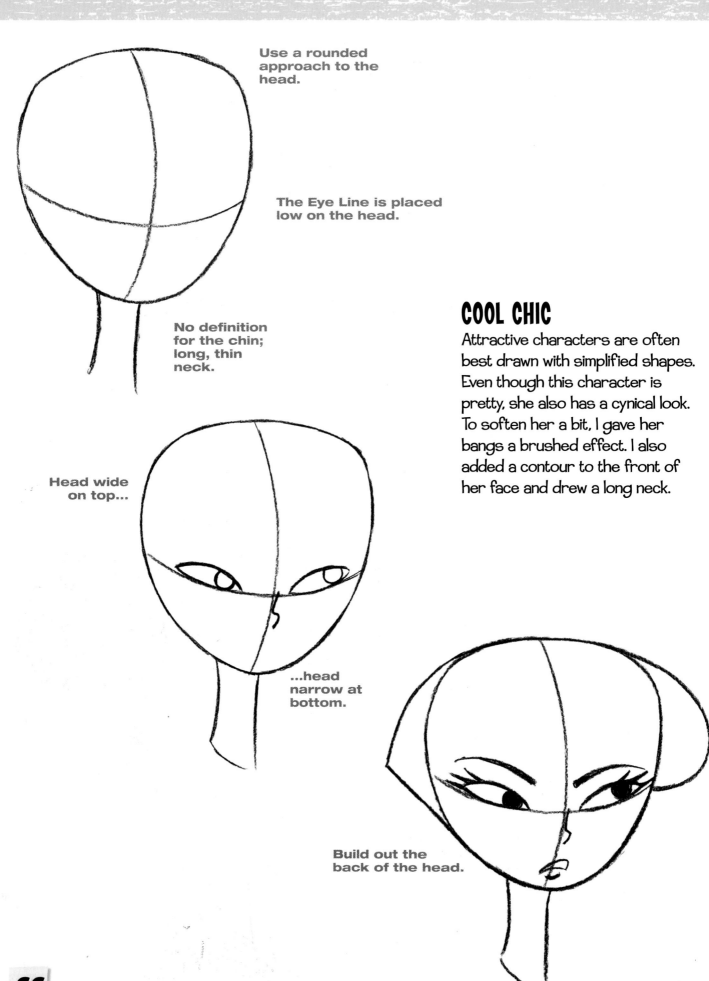

Use a rounded approach to the head.

The Eye Line is placed low on the head.

No definition for the chin; long, thin neck.

Head wide on top...

...head narrow at bottom.

COOL CHIC

Attractive characters are often best drawn with simplified shapes. Even though this character is pretty, she also has a cynical look. To soften her a bit, I gave her bangs a brushed effect. I also added a contour to the front of her face and drew a long neck.

Build out the back of the head.

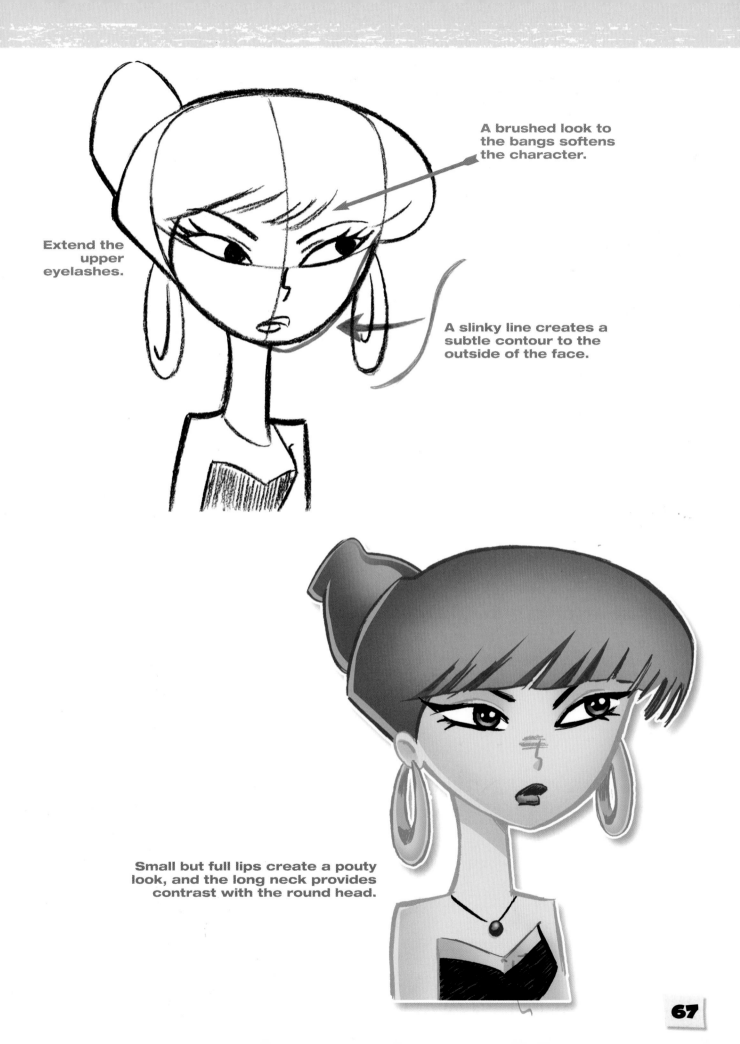

A brushed look to the bangs softens the character.

Extend the upper eyelashes.

A slinky line creates a subtle contour to the outside of the face.

Small but full lips create a pouty look, and the long neck provides contrast with the round head.

67

AMERICAN MIDDLE-AGED MAN

He commutes over an hour each day. His boss doesn't remember his name. He gets promotions, but never a raise. When he arrives home, his dog plays tug of war with his pant leg. His children have their hearts set on the most expensive colleges on the East Coast. He'll pay off his mortgage just before the sun goes supernova. No one in the family allows him to possess the remote control. So what does he do for fun on the weekends? He paints the white picket fence.

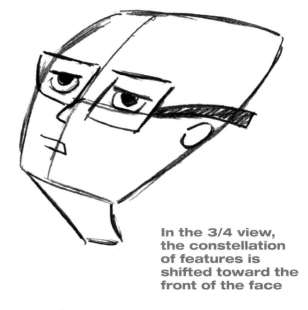

In the 3/4 view, the constellation of features is shifted toward the front of the face

Front and back of head drawn on a tilt

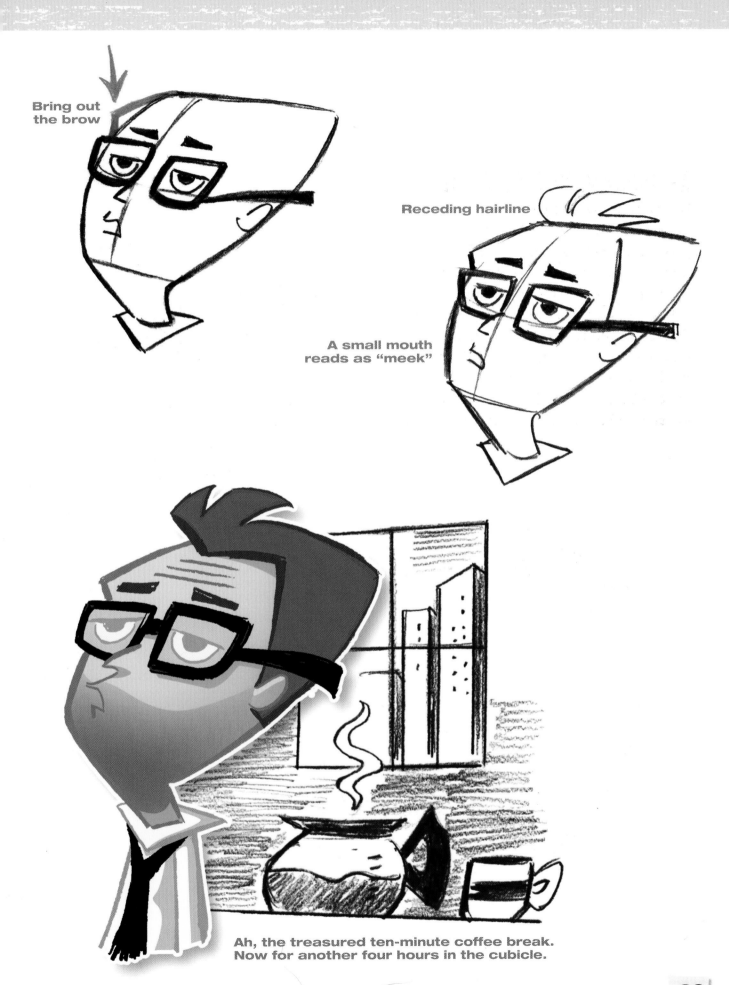

Bring out
the brow

Receding hairline

A small mouth
reads as "meek"

Ah, the treasured ten-minute coffee break.
Now for another four hours in the cubicle.

REFINING THE HEAD SHAPE

This chapter separates the men from the boys. The women from the girls. The mammals from the crustaceans. What I mean to say is that you are about to gain a deeper insight into the process of character design than you ever had before.

You're about to learn how to create a character type from the first pencil stroke, before you even position the features of the face. I can hear the outcries now: "How can this be?" To which I retort, "Oh, it be. It very definitely be." Generally speaking, the human head is the shape of a hard-boiled egg, with the wider part on top, the smaller end at the bottom, and the runny part in the middle. Where most beginners go wrong is that they rely too heavily on the features to create a unique look. In other words, they wait until they have the outline of the head in place before getting creative. We're going to get funny right, right from the start.

7 BASIC ELEMENTS OF THE HEAD

There are seven aspects of the head that we can exaggerate, minimize, and adjust to create interesting character types. They are as follows:

- Top of the head
- Back of the head
- Line of the back of the head (which extends from the neck to the ear)
- Line of the jaw (the line connecting the angle of the jaw, below the ear, to the chin)
- Chin
- Cheekbone
- Forehead brow

CLASSIC MALE HEAD - STARTING POINTS

The egg shape can start out the same for males and females. From there, we begin to make adjustments in order to individualize the character.

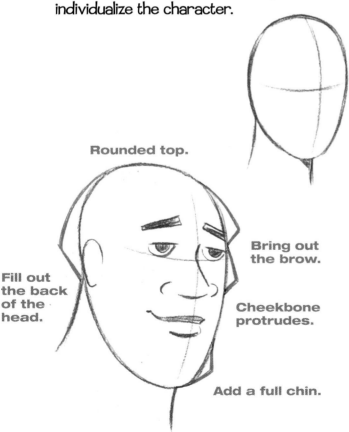

Rounded top.

Fill out the back of the head.

Bring out the brow.

Cheekbone protrudes.

Add a full chin.

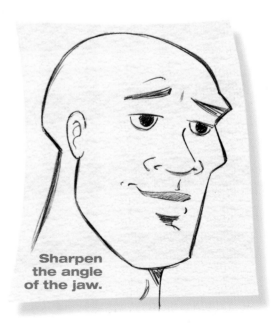

Sharpen the angle of the jaw.

FUNDAMENTAL HEAD SHAPES FOR CARTOONISTS

Now we come to the part of the book that you've all been waiting for: creating funny, original characters based on the overall head shape.

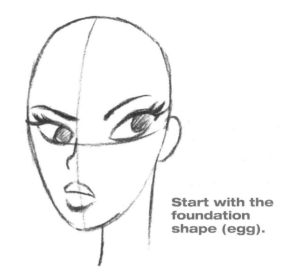

Start with the foundation shape (egg).

Flatten the top of the head for a severe look, but add size to the back.

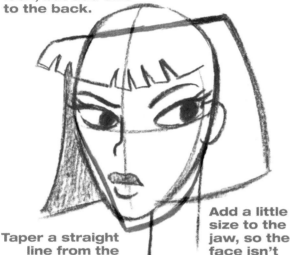

Taper a straight line from the cheekbone to the tip of the chin, ending at a point.

Add a little size to the jaw, so the face isn't too narrow.

SEVERE HEAD SHAPE: SHARP LADY

Give a sharp look to the brows, cheeks, or chin to create a severe look or make a character appear to be rich, haughty, or evil.

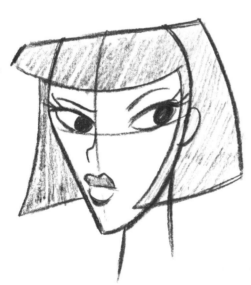

Revised construction, ready for the final drawing.

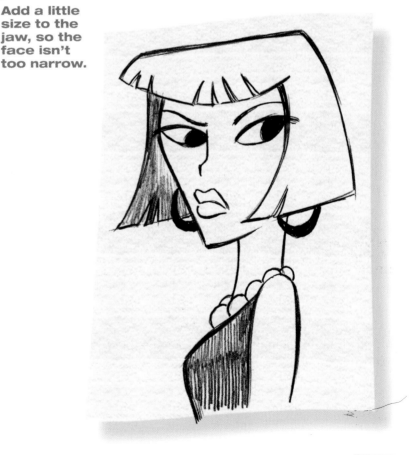

SMALL CRANIUM: GRAMPS

Older characters are popular in animated TV shows. They make great characters, from the doting grandma to the cantankerous neighbor. We'll start with a typical head shape for a cartoony senior citizen: a small cranium on top of a long and pronounced jaw. Then we go to work, exaggerating the areas of the head that give the appearance of age.

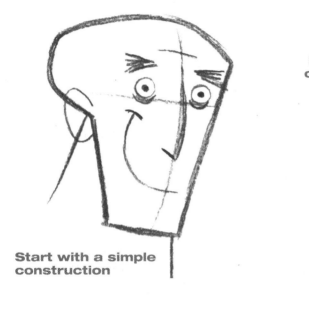

Start with a simple construction

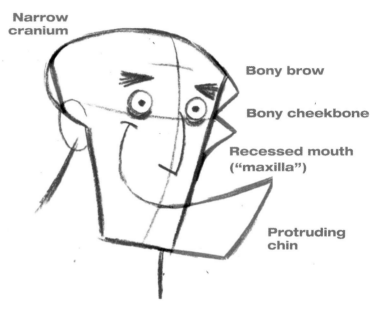

Narrow cranium

Bony brow

Bony cheekbone

Recessed mouth ("maxilla")

Protruding chin

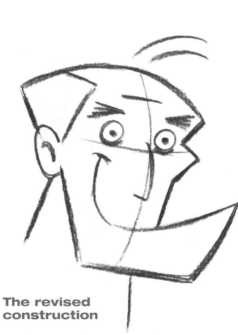

The revised construction

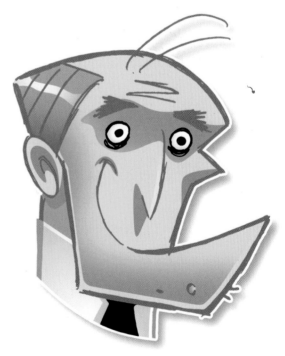

Compare the finished sketch with the first foundation step: a series of minor changes to the structure of the head adds up to a significant enhancement of the character.

BLOCK HEAD: OFFICE GUY

The typical middle-aged corporate guy is a temple of conformity. Our job, as cartoonists, is to convey his corporate-culture mindset. I like to use a blockhead shape, because he is incapable of thinking outside of the box. He is the box.

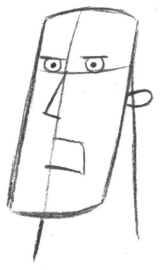

Foundation shape: rectangle

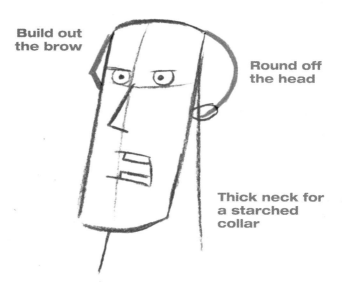

Build out the brow

Round off the head

Thick neck for a starched collar

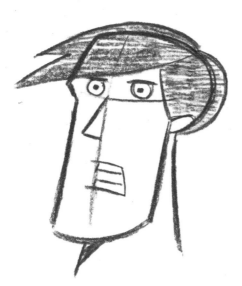

The revised construction.

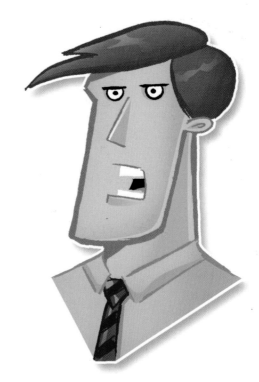

The long, straight lines used to create this character give him the look of corporate culture.

75

EGG OR OVAL: YOUNG TEEN

A plain and simple construction works well for teenage heads. But we need to spruce it up a touch by adding just a few variations to the basic outline. Notice that none of the variations appear on the front of his face. It's been left as a smooth, rounded line, which conveys youth.

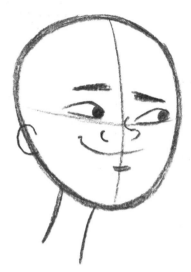

Start with a simple round shape.

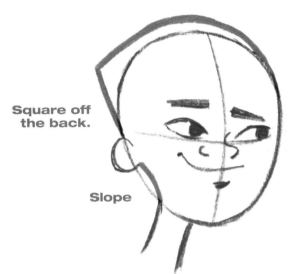

Square off the back.

Slope

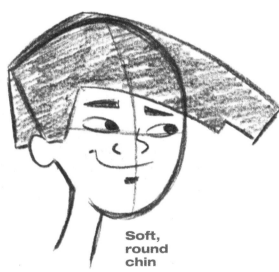

Soft, round chin

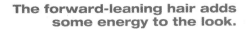

The forward-leaning hair adds some energy to the look.

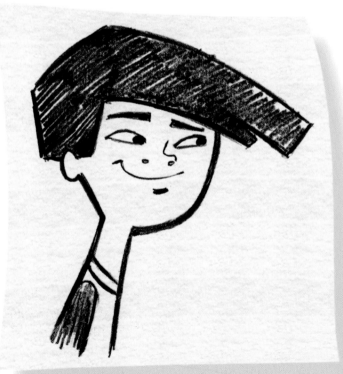

LONG-JAW: DOPEY DAD

Although rarely the star, the feckless father type can be a hilarious supporting character, and the brunt of a lot of unkind–but funny–humor.

The fun of this character type is that you can mold the head into extreme shapes. Draw a silly head shape, put glasses and thinning hair on it, and voila! "Dad." A dad will have an adult head construction: a smaller upper head (cranium) and a larger–or longer–jaw area. Other things that add age are longer ears and a pointy nose.

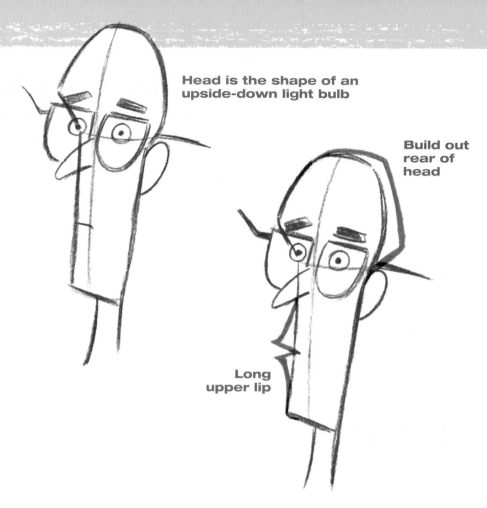

Head is the shape of an upside-down light bulb

Build out rear of head

Long upper lip

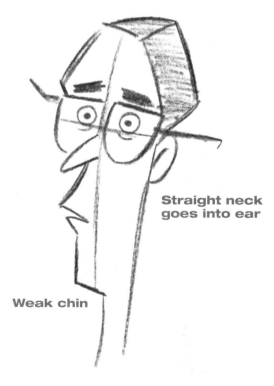

Straight neck goes into ear

Weak chin

And to think he's the one who taught you all about life.

TAPERED CHIN: PRETTY WOMAN

There's a common belief that pretty female characters are only drawn with soft and subtle lines. I want to dispel that belief right now. The signature look of the pretty character is a small mouth area and a tapered chin.

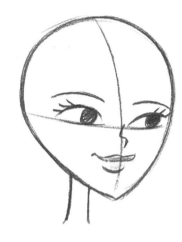

Start with an egg-shaped head, but let the chin come to a gentle point.

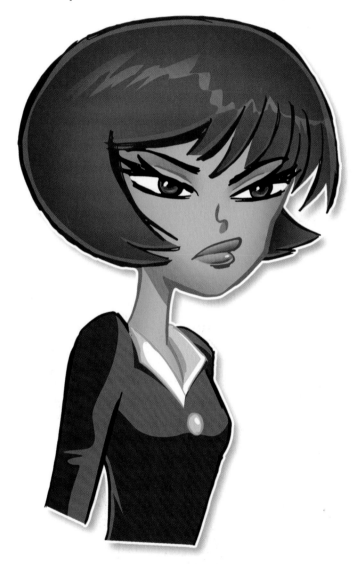

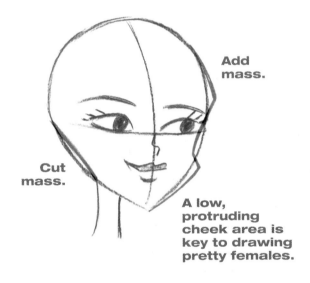

Add mass.

Cut mass.

A low, protruding cheek area is key to drawing pretty females.

Let's stipulate right now that sharp angles are neither inherently masculine nor feminine. Instead they are used to convey a flat and graphic style.

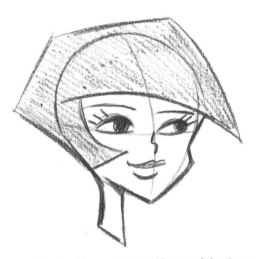

Note the proportions: big top of the head, smaller lower part.

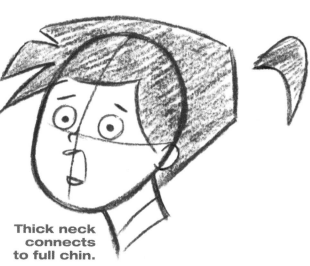

Nice basic shape but it still needs some work to be a unique character.

ROUNDED: OVERWHELMED STUDENT

Not all teenage characters are tall and lanky. Other body types require head shapes to match. This one's a little pudgy.

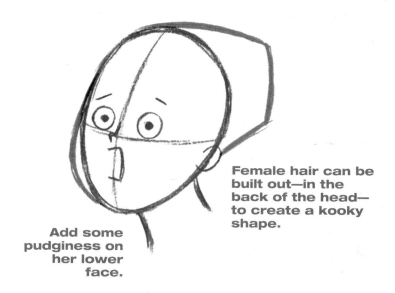

Add some pudginess on her lower face.

Female hair can be built out—in the back of the head— to create a kooky shape.

Thick neck connects to full chin.

Squaring off the back of the head gives the character a cartoony style.

CHAPTER 5

EXAGGERATION

Exaggeration is an important principle in creating cartoon characters. But if you give every part of the head and features the same emphasis, you'll end up with no emphasis. The best cartoon characters are built with one or two aspects of the head overshadowing the others. Most readers remember characters by their prominent features, such as, "That cartoon guy with the funny eyes," or "The goofy character with the skinny face." Therefore, prioritizing which features to exaggerate is essential.

An important note: exaggeration doesn't always mean making something bigger. Some features can draw attention to themselves because they are unusually small. For example, if you were to draw a hefty character with beady little eyes, the eyes would become the exaggerated feature.

EXAGGERATED PROPORTIONS

What's the standout aspect of this character? The eyes, right? Mmm, yes and no. The eyes are big, but they're that way because the enormously exaggerated head shape allows for it. Therefore, the most important aspect of this character's design is the exaggerated size of her upper head. This is also what causes the hair to appear so massive.

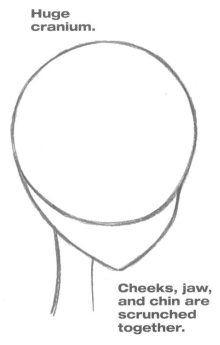

Huge cranium.

Cheeks, jaw, and chin are scrunched together.

Hair adds even more size to the upper head.

A skinny neck is funny, as it supports that big head.

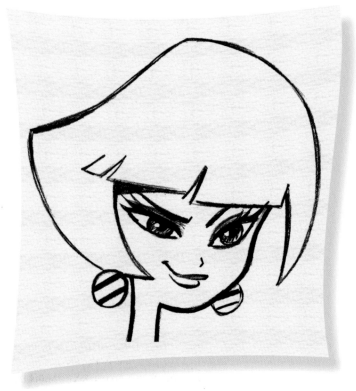

I'd hate to see that smile directed at me.

EXAGGERATED OVERBITE

Eyes are in a 3/4 view.

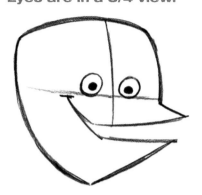

Mouth is in a side view.

We've all broken the rules at one time or another, whether it's skipping a class, swiping an office pen, or racketeering. In cartooning, rules are called "conventions." It simply means that the viewer expects to see the head constructed in a conventional, logical manner. When a convention is broken, it draws attention to itself and, if done in a funny way, creates a wickedly funny character.

The character on this page is shown in 3/4 view, but his mouth has been drawn in a strict profile. It looks wrong. Really wrong. And, therefore, really funny.

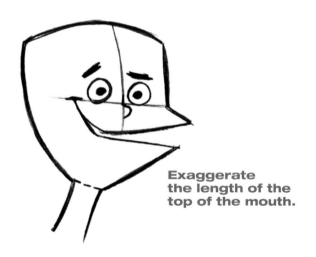

Exaggerate the length of the top of the mouth.

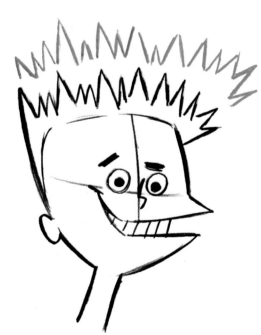

Add a second tier of exaggeration: insane hair.

The teeth are all crooked. To add more fun, the mouth widens as it travels forward toward the outline of the face.

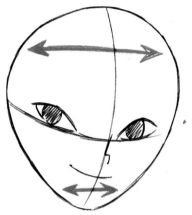

Very wide head

Very narrow chin

EXAGGERATED TAPER

When a character doesn't have any single feature that stands out, you can still create a unique look by drawing the face with a significant taper. The face of this cartoon gal starts off wide, and then tapers almost to a point at the chin. It is almost a manga head shape. A tapered face gives the character a sharper, more stylish look.

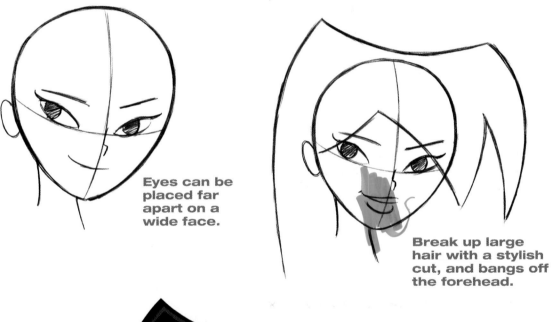

Eyes can be placed far apart on a wide face.

Break up large hair with a stylish cut, and bangs off the forehead.

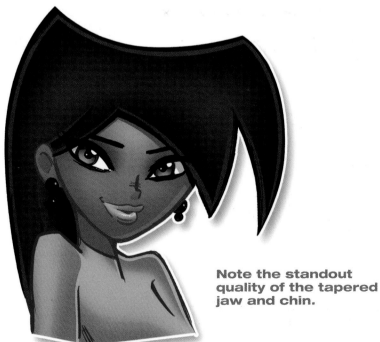

Note the standout quality of the tapered jaw and chin.

EXAGGERATED FOREHEAD

If you could grab a person's face and push his features toward the bottom of his head, you would see that the forehead appears larger. I love creating super-glum characters like this morose 12-year-old. No, Billy, you can't use your chemistry set to experiment on the cat.

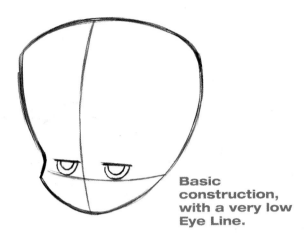

Basic construction, with a very low Eye Line.

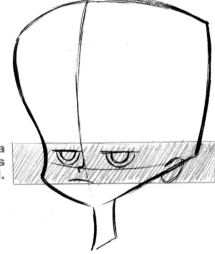

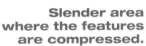
Slender area where the features are compressed.

Overwhelming hair completes the look.

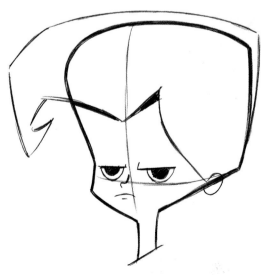

The oversized forehead acts like an anvil, flattening the features.

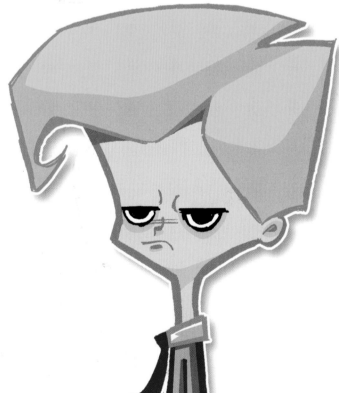

EXAGGERATED NECK

Just as the face can taper down toward the chin, it can also expand into a fat neck. This approach results in ridiculous characters, and with cartoons, ridiculous is good. For some architecture inside that giant face, we have given him a protruding chin.

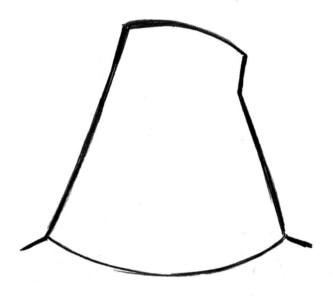

Super-wide neck

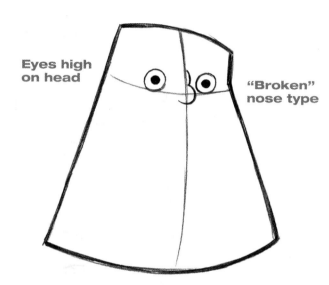

Eyes high on head

"Broken" nose type

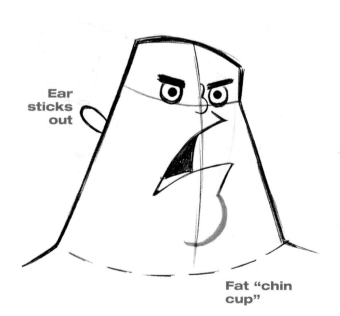

Ear sticks out

Fat "chin cup"

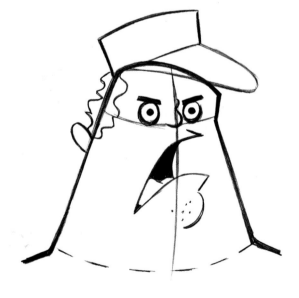

Big mouth dips low on head

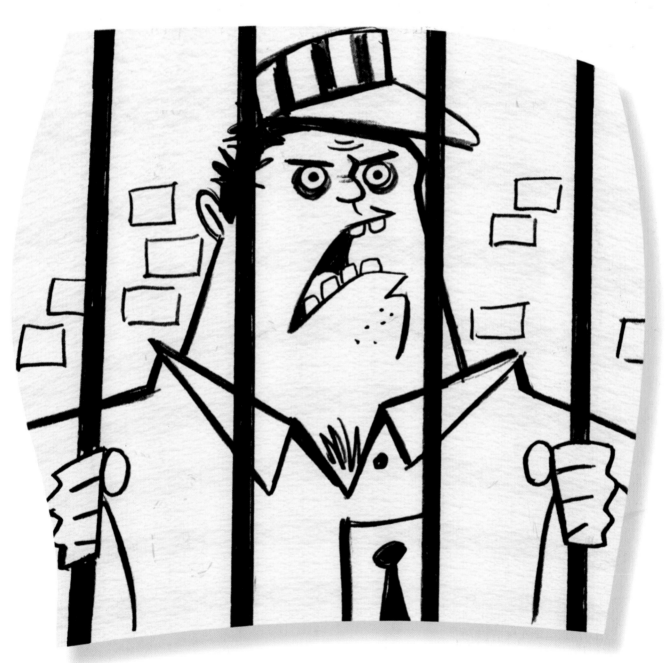

With good behavior, he might get his
sentence reduced to 799 years.

DYNAMICS OF THE FACE

The cartoon face isn't a static object. It's like a rubber ball, but with occasional acne. Different expressions cause the head to compress or lengthen. This brings us to the principle of "Squash & Stretch." When you squash or stretch the head, the features also squash and stretch as a result. And this can make for some very funny expressions.

SQUASH & STRETCH

One of the most effective ways to increase the humor in an expression is with a technique called "Squash & Stretch." The effect should appear to be the direct result of the character's expression. For example, a wide mouth causes the sides of the face to push outward. Conversely, a toothy grin is more vertical, and has the effect of stretching the face from the top and bottom.

NORMAL
Ordinary poses and expressions use little squash and stretch.

SQUASHED
The wide mouth forces the head to get wider (squash). This leaves so little room for the eyebrows that they have to be drawn outside the outline.

STRE-E-E-ETCHED
A toothy smile has long vertical lines, stretching the head from top to bottom to make room!

SQUASH & STRETCH: PUTTING THE CONCEPTS TO WORK

Let's apply the Squash & Stretch concept to a few different cartoon faces. An important, but sometimes overlooked, aspect of this technique is that the features are directly affected by Squash & Stretch.

BASIC HEAD SHAPES

Simple shapes, such as circles, ovals, and eggs are easy to squash and stretch. For this example, we'll use an egg-shaped head.

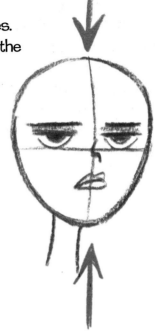

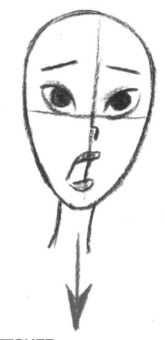

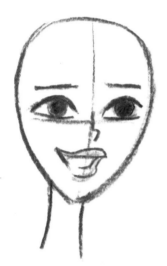

SQUASHED
As the head contracts, features are scrunched together and subtly squashed: here the eyes are flatter.

STRETCHED
Surprised expressions are stretched: the eyes, nose, and mouth pull away from each other.

NORMAL
The features of the face are in their default position.

UNIQUE HEAD SHAPES

It's easy to Squash & Stretch a circle. But some head shapes are more challenging because they're not based on simple, recognizable shapes like a circle or an oval. In those instances, we need to limit the effect or we'll be in danger of losing the integrity of the character's basic look. We need to simplify the approach.

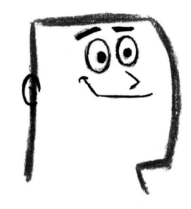

NORMAL
The head's "normal" appearance, without Squash & Stretch.

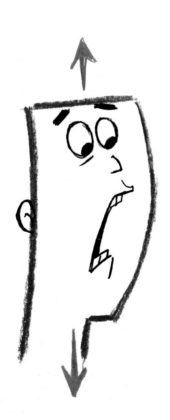

STRETCHED
The head takes on a vertical look.

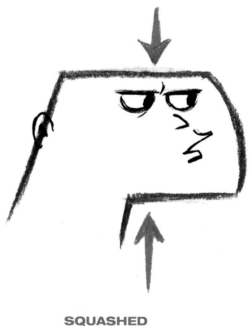

SQUASHED
The head takes on a horizontal appearance.

LIMITED SQUASH & STRETCH

In the olden days of animation, before there was fire, Squash & Stretch used to mean a huge exaggeration of the face. But with the advent of running water and those new-fangled phones, other techniques for drawing expressions began to appear. Nowadays, Squash & Stretch is not nearly as bold as it used to be. But even when used on a more limited basis, Squash & Stretch makes an expression look funnier.

NORMAL
(If you can call this goofy guy "normal"!)

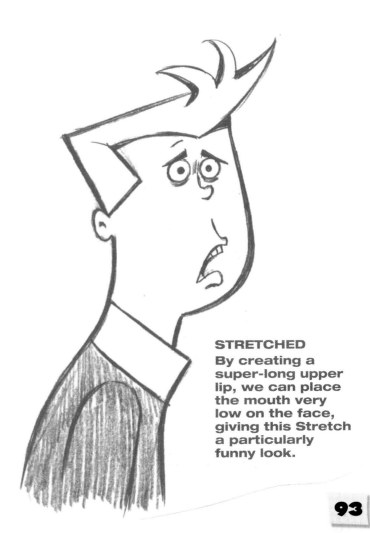

SQUASHED
The hair is the only part of the head that doesn't experience a degree of Squash.

STRETCHED
By creating a super-long upper lip, we can place the mouth very low on the face, giving this Stretch a particularly funny look.

93

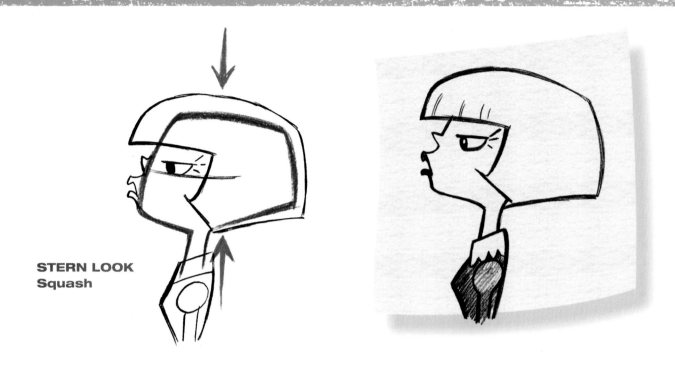

STERN LOOK
Squash

SQUASH & STRETCH - VARIOUS EXPRESSIONS

To get a feel for the ubiquity of the Squash & Stretch technique (I've been waiting since 7th grade to use "ubiquity" in something other than a pop quiz), I've drawn a number of popular cartoon expressions. I've got a plethora of them, each of which is underscored by a degree of Squash & Stretch.

PUZZLED
Squashing the entire shape would be too extreme, so I've squashed only one aspect of the face.

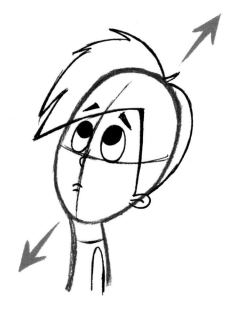

INNOCENCE
This head combines a "tilt" and a "stretch" in order to get that innocent look that is so appealing on cute character types.

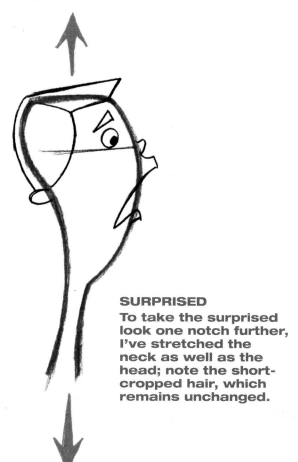

SURPRISED
To take the surprised look one notch further, I've stretched the neck as well as the head; note the short-cropped hair, which remains unchanged.

STRETCHING THE NECK

You can use the length of the neck to add an accent to expressions. Often, you'll find that the wider the eyes become, the longer the neck gets. Conversely, the narrower the eyes get, the lower the head sinks onto the body. Of course, there are exceptions to every rule. Like the one about doing unto others the way you would like them to do unto you. Yeah, like that's really going to happen.

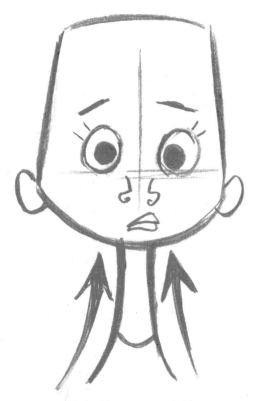

The eyes grow large, and the neck stretches to underscore the surprised expression.

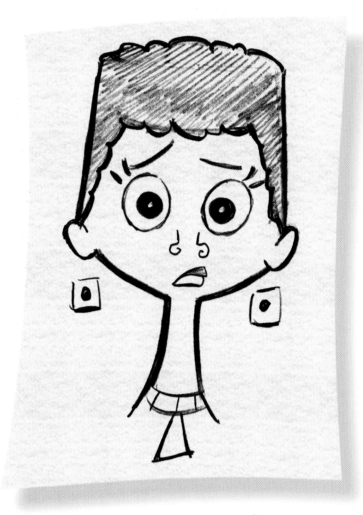

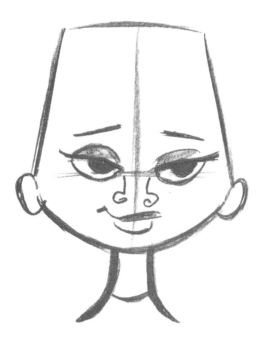

The eyes settle into a narrower shape, and the neck responds by shortening.

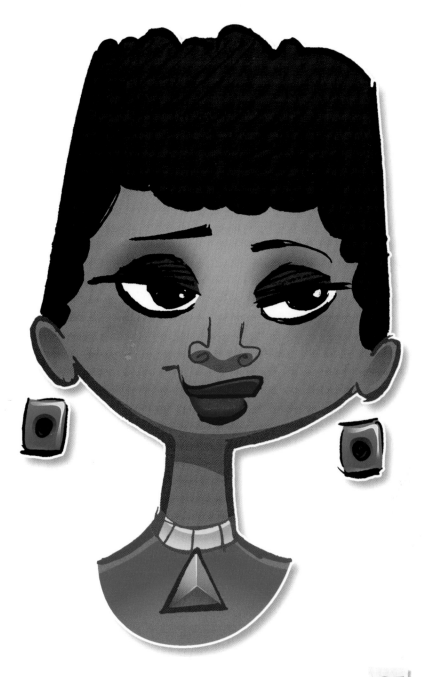

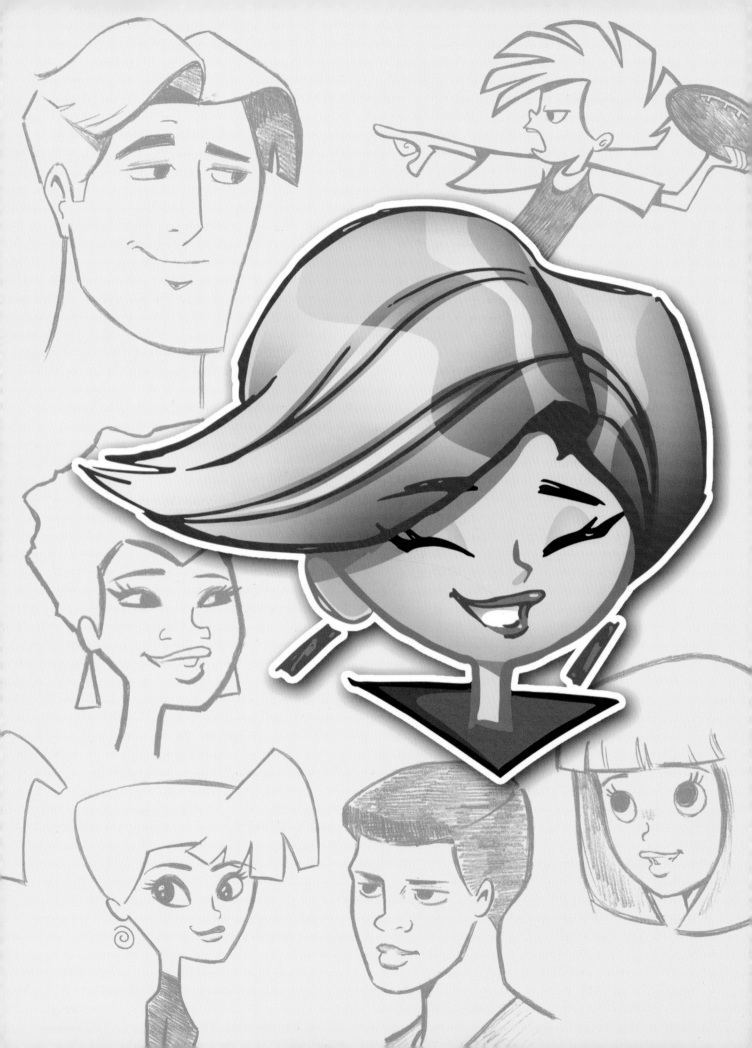

HAIRSTYLES

Hold on to your seats, because I am about to reveal the most overlooked tool in cartooning: hairstyles. You can let go of your seats now.

Aspiring cartoonists often draw the hair last on a character, as an afterthought. But it's actually as integral to the look of a character as any of the features. If your character has a huge hairdo, the viewer will begin to recognize the character as having an oversized head. They won't think of it as simply "big hair" on a normal-sized head. In this way, the size and shape of the hairdo become synonymous with the size and shape of the head. The hair becomes part of the basic look and structure of the character.

As we begin to draw different hairstyles, I'd like you to notice three main concepts:

1) Each hairdo is consistent with the style of the character.
2) The hair adds size to the head.
3) The hair can be drawn with curved lines or hard angles.

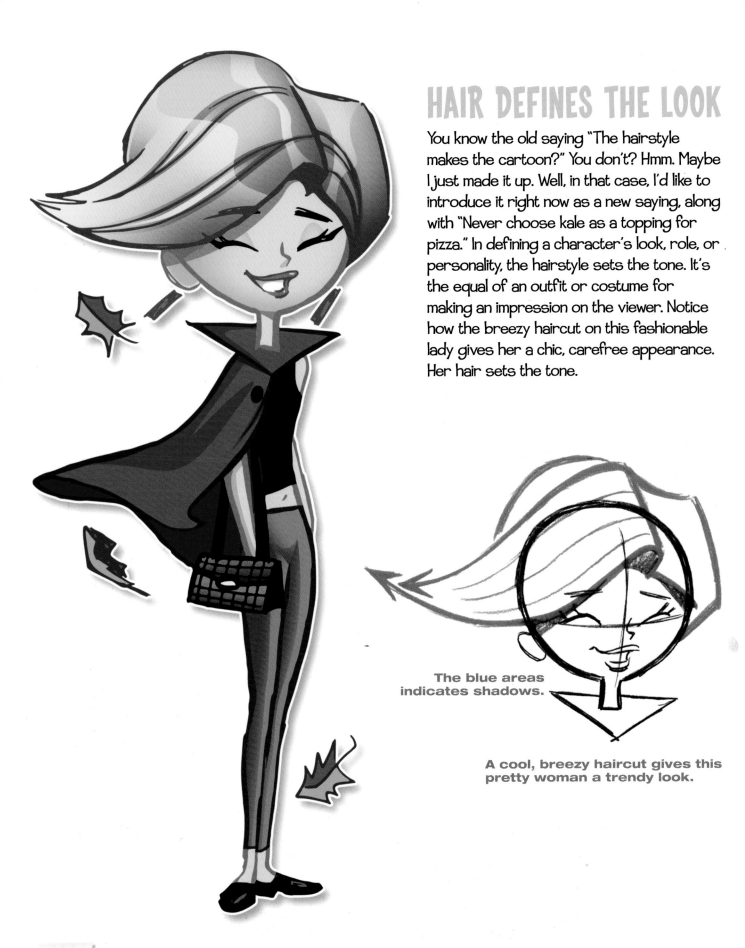

HAIR DEFINES THE LOOK

You know the old saying "The hairstyle makes the cartoon?" You don't? Hmm. Maybe I just made it up. Well, in that case, I'd like to introduce it right now as a new saying, along with "Never choose kale as a topping for pizza." In defining a character's look, role, or personality, the hairstyle sets the tone. It's the equal of an outfit or costume for making an impression on the viewer. Notice how the breezy haircut on this fashionable lady gives her a chic, carefree appearance. Her hair sets the tone.

The blue areas indicates shadows.

A cool, breezy haircut gives this pretty woman a trendy look.

FEMALE HAIRCUTS

SHORT & STYLISH

This type of cut is popular for fashionable cartoon characters. It's quite full, and therefore adds size around the head. The pointed tips give it a retro look.

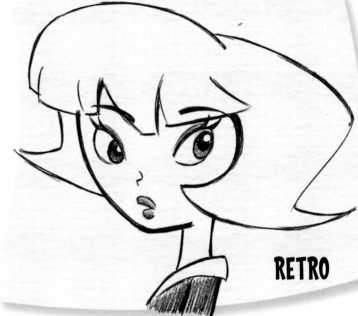

RETRO

Float eyebrows over the bangs, for fun.

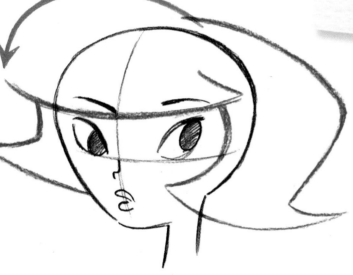

TRENDY

Brushed effect breaks up bangs.

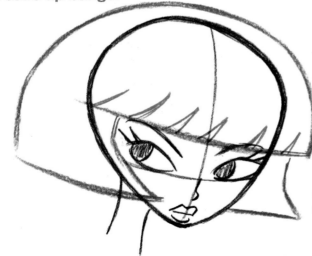

Cropped just above chin gives the hair a trendy look.

EXAGGERATED CURVES

For long, wavy female hair, you'll need to exaggerate the curves even more.

Deep curves give the hair an organic feel. The squiggles align with one another for a stylish, comical look.

BOB CUTS

The bob (or blunt cut) is super-popular, and a good choice when you're undecided about which haircut to draw. It's hard for a character *not to look good* in a bob. It's flattering for young and middle-aged adults.

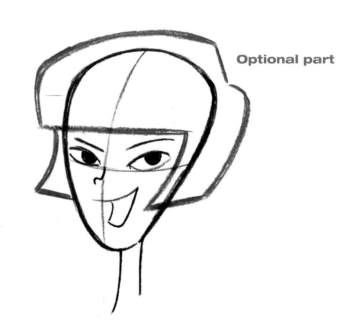

Optional part

STRAIGHT BANGS

It's important to add some casual streaks to straight bangs, or the hair will look like a hat.

SWEPT BANGS

Streaks and jagged lines are used to show movement of the bangs to one or more sides of the face.

Bangs swept to one side

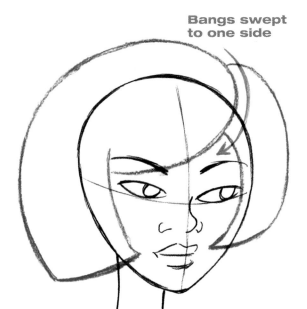

ANGLED CUT

The hair that hangs lower at the sides of a bob cut is usually drawn with curved lines to indicate movement and perspective.

Soft look: the hair has natural curves. It's a relaxed look.

Hard look: straight hair

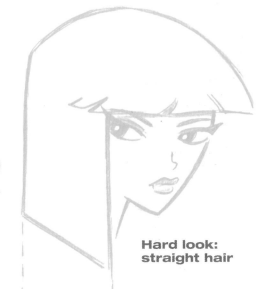

CASUAL HAIRSTYLE

In addition to the shape of the hairdo, the hair itself has a certain quality. This woman's hair appears brushed smooth.

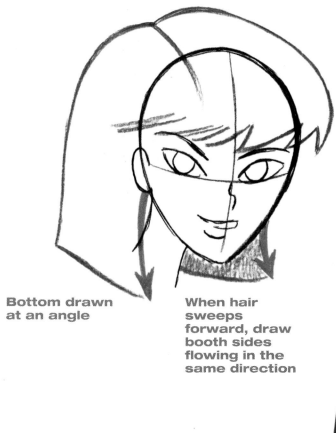

Bottom drawn at an angle

When hair sweeps forward, draw booth sides flowing in the same direction

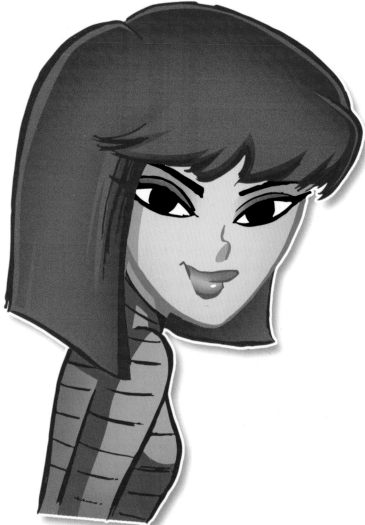

PONYTAILS

The ponytail remains an ever-popular style for cartoon kids and teens. Young boys find ponytails particularly irresistible as handles. I prefer to draw them "floating" just off of the head, to give the cartoon a flat, graphic quality. But it's just as popular to attach it. Don't let it wilt-unless that's the look you're going for. Add some curves for life and buoyancy.

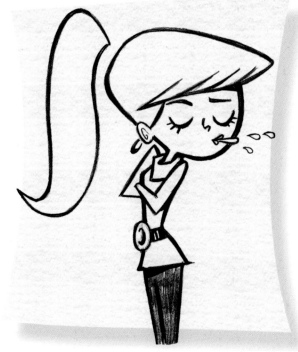

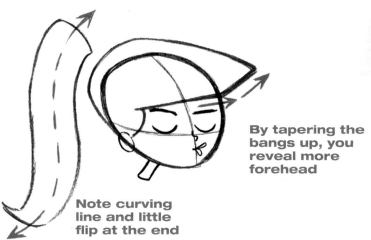

By tapering the bangs up, you reveal more forehead

Note curving line and little flip at the end

Headband adds further interest

Bump up a notch before going down

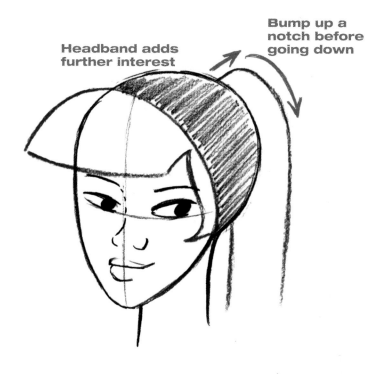

105

UNUSUAL HAIRSTYLES

When your character looks okay, but not quite eye-catching, try getting more creative with the hairstyle.

WIDE TOP

This female sports a hairstyle that makes her look like a fashionable young woman out on the town.

The top takes up a lot of room, but tapers swiftly toward the ears.

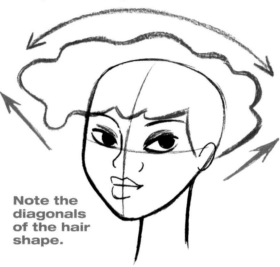

Note the diagonals of the hair shape.

EGYPTIAN QUEEN

This hairdo is appealing and unusual, because it's vertical.

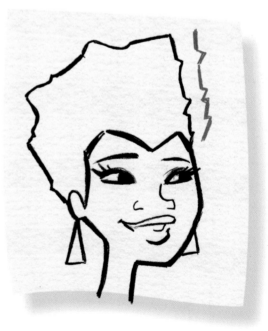

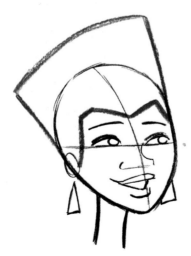

Have fun with the hard angles that create the outline. A slightly jagged line keeps it looking natural.

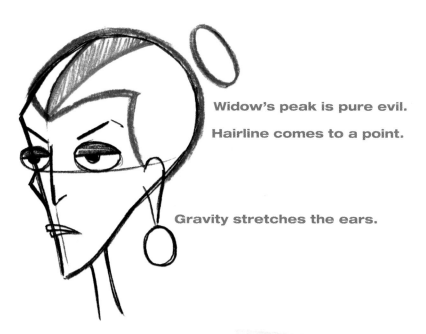

Widow's peak is pure evil.

Hairline comes to a point.

Gravity stretches the ears.

EVIL NEIGHBOR

This hairstyle works best on a "killjoy" type character. When I was growing up, I had a neighbor who hated Halloween and boys, not necessarily in that order. Now, having grown up, I look back on those times with a different set of eyes. I imagine stopping by the old neighborhood, ringing her doorbell, and having a nice chat. And then, after she goes back inside, toilet-papering all the trees in her yard.

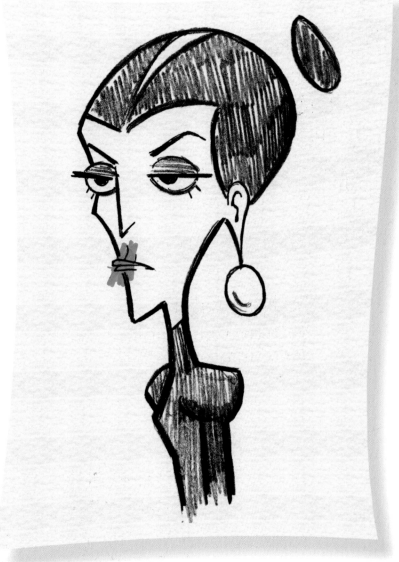

MALE HAIRCUTS

Whereas much of the female hairstyle takes place in the back of the head and behind the ears, male hair is mostly defined by the way the hair is drawn just above the forehead. Behind the head, the male hairdo generally tapers to the base of the neck.

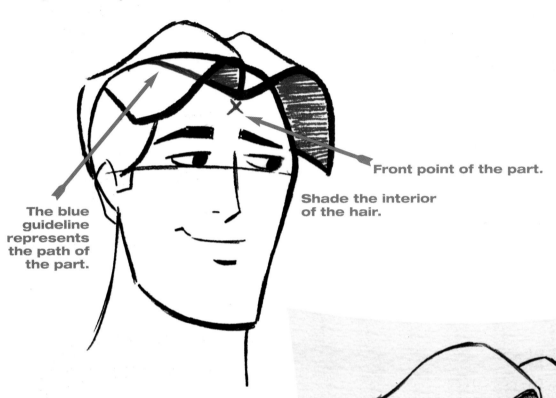

Front point of the part.

Shade the interior of the hair.

The blue guideline represents the path of the part.

FLOPPED OVER

When you are a suave guy who spends a lot of time on your hair, you get a lot of admiring looks—by glancing continually at the mirror.

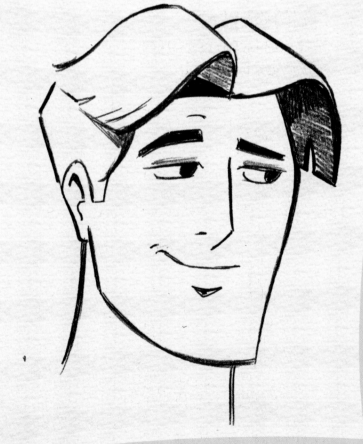

OVER THE FOREHEAD

This look is the most common type of teen hairdo, flopping forward.

An indentation is helpful in defining the part.

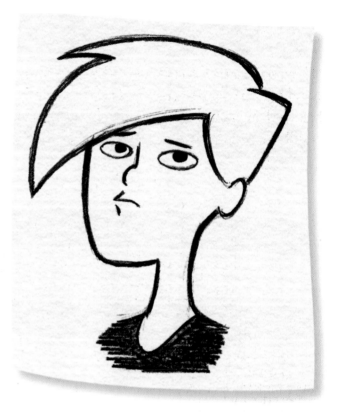

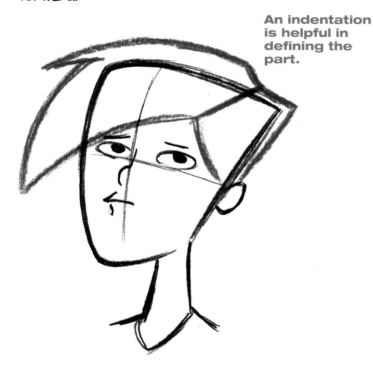

FLIPPED BACK

A carefree flip from the front is a funny look.

Add ruffles to the flip.

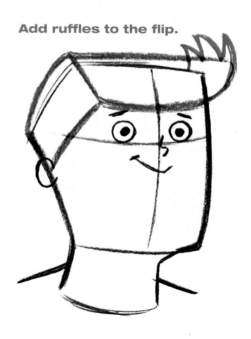

ADDED SIZE IN THE FRONT

You can bring the front of the hair forward, to add a little style.

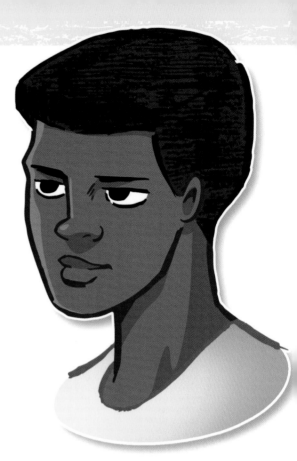

The broken lines indicate thickness.

Hairline is high on the forehead.

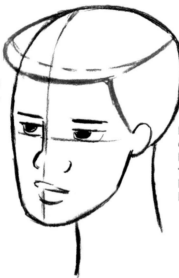

Natural slope of the skull is lower in the front, but higher in the back.

SHORT HAIR

You have to be confident that you've planned the entire head shape the way you want it before you draw this hairstyle. That's because it's cropped so close to the skull that it shows all of the contours of the head.

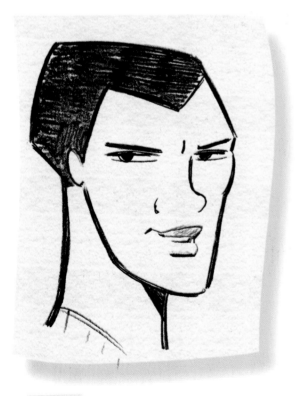

ADDED STYLE

Follow the outline of the head and draw in a hairline around the face using straight lines and sharp angles.

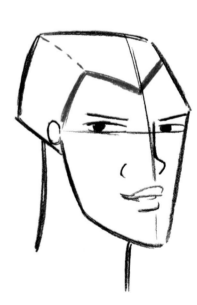

The dotted line shows that the part originates at the angle at the top of the head.

VERY FULL HAIR

On many characters, the hair takes up a significant percentage of the overall head size. Don't worry about the hair competing with the face. If the hair is so funny that it steals the show, you did good!

BIG HAIR - BUMPY

Super-fluffy hair is cute on young boys. And on older gentlemen, Einstein-like.

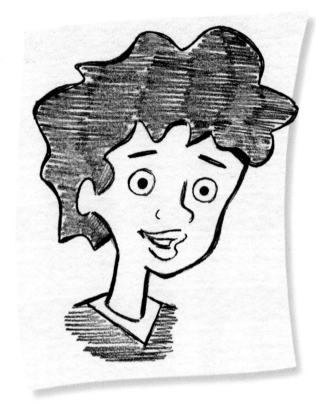

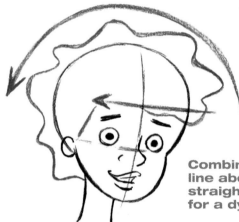

Although it appears to have no overall outline, the hair is loosely drawn using an arching guideline.

Combine an arched line above with a straight line below it for a dynamic look.

BIG HAIR - SMOOTH

You can create hair dimension and weight without the fluff. Here's how.

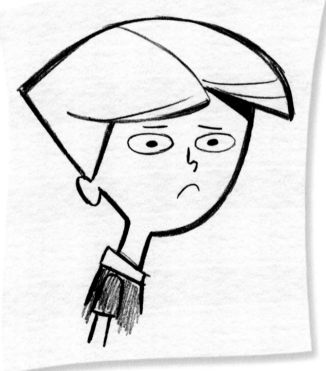

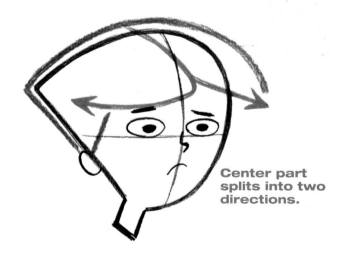

Center part splits into two directions.

Overhang of hair casts a shadow on the forehead below.

HAIR: PUTTING THE CONCEPTS TO WORK

Now we're ready to put it all together. We'll start with the basic construction of the head, then add the features, tweak the expression, and create the hairstyle.

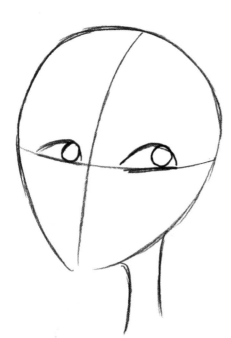

Egg-shaped head

STYLISH HAIR

There's a lot going on with this hairdo: a shaggy front, flip in back, curl above the ear, and a side part. You can prevent it from looking busy by prioritizing the emphasis you place on each element. For example, the shag in front is the largest accent, followed by the flip in back. And the curl above the ears is a detail.

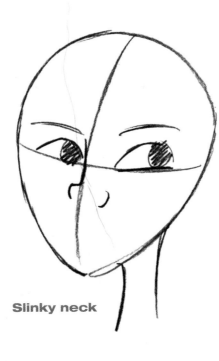

Big eyes in the corners

Slinky neck

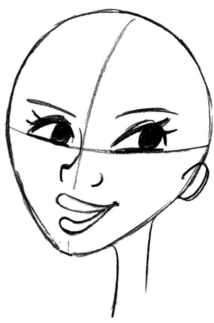

Lips face 3/4 view, left

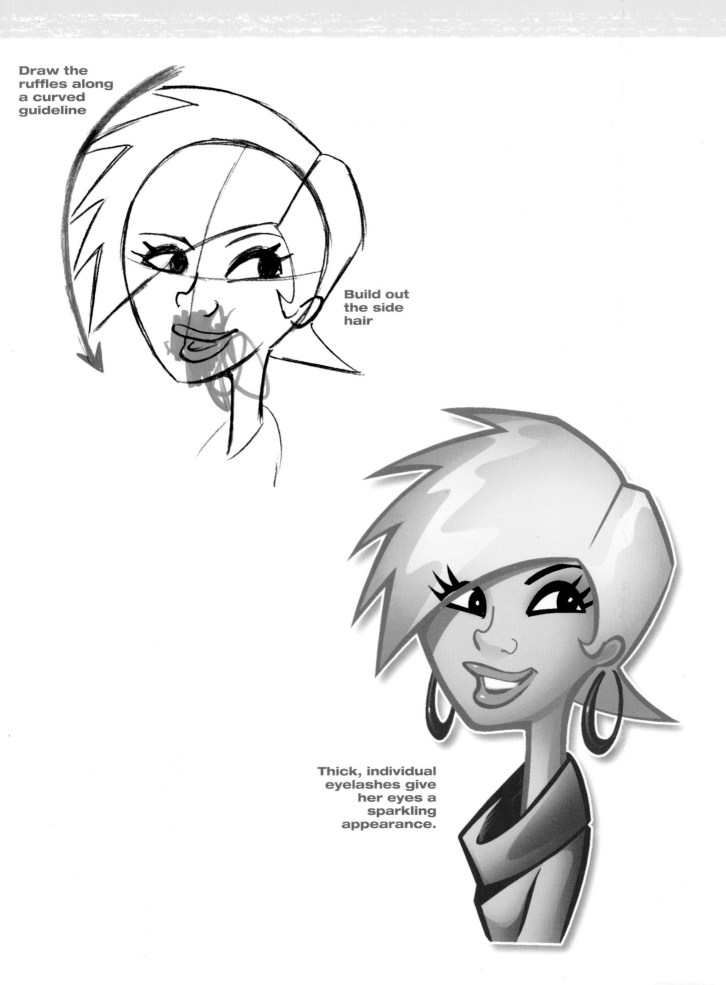

Draw the ruffles along a curved guideline

Build out the side hair

Thick, individual eyelashes give her eyes a sparkling appearance.

113

FLAT TOPS

I like this type of a cartoon haircut, because it's just plain funny-looking. The "flat top" hairstyle looks as if it were made by running a pair of gardening shears across the top of someone's head.

WIDE TOP

Wide, but still flat-top, hair works, too.

We start with a rounded head shape, as usual. But as we proceed, we accommodate the flat hairstyle so that it literally changes the shape of the top of the head.

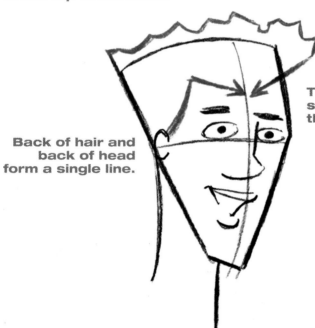

The hair angles sharply inward at the Center Line.

Back of hair and back of head form a single line.

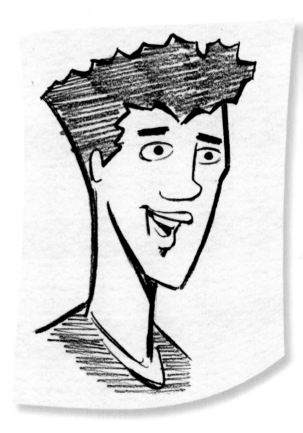

WILD HAIR

Can you do this with a brush and a comb? Nope. That's because you're not a cartoon. But if you were, this jagged hairstyle would be a great way to show people that you're not just any old cartoon nerd, but you're a *way-cool* cartoon nerd. Hair that combs upward always gives a funny impression. You might be stumped as to what type of outfit goes with that haircut. The answer is: none. Absolutely nothing goes with this haircut. That's the fun of it!

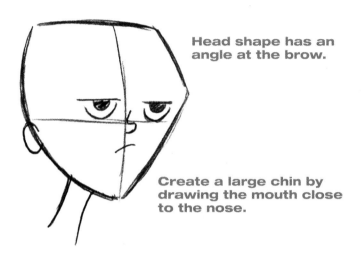

Head shape has an angle at the brow.

Create a large chin by drawing the mouth close to the nose.

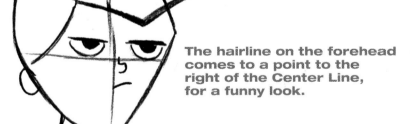

The hairline on the forehead comes to a point to the right of the Center Line, for a funny look.

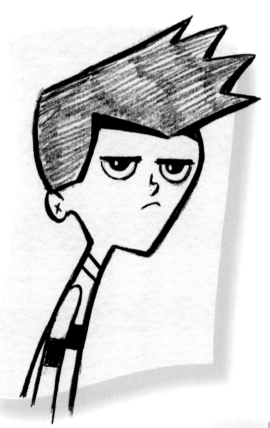

Aw, why the glum face? Did the person you were stalking move away?

115

Head in profile

PUNK HAIR

Teen haircuts can border on the bizarre. This is usually the first sign of normal adolescent rebelliousness. Next come tattoos, followed by body piercing, and elaborate outfits. But what really freaks parents out is when their kid goes off to college, and ends up joining a strange society where everyone wears suits and ties: the College Republicans.

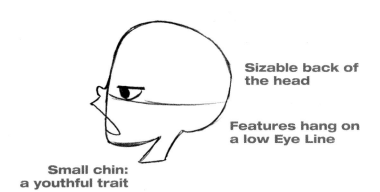

Sizable back of the head

Features hang on a low Eye Line

Small chin: a youthful trait

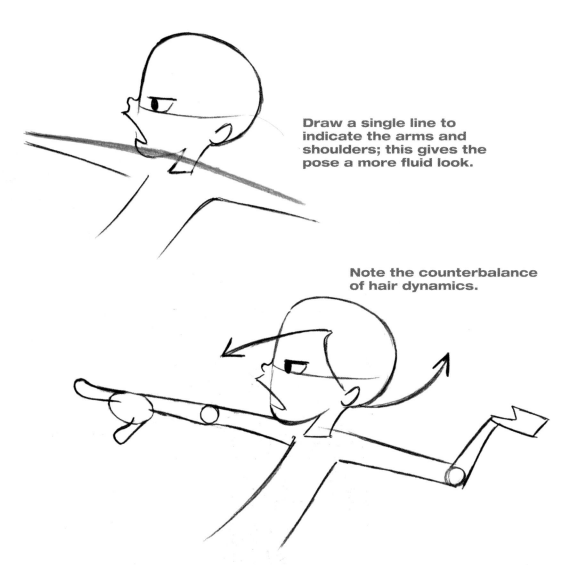

Draw a single line to indicate the arms and shoulders; this gives the pose a more fluid look.

Note the counterbalance of hair dynamics.

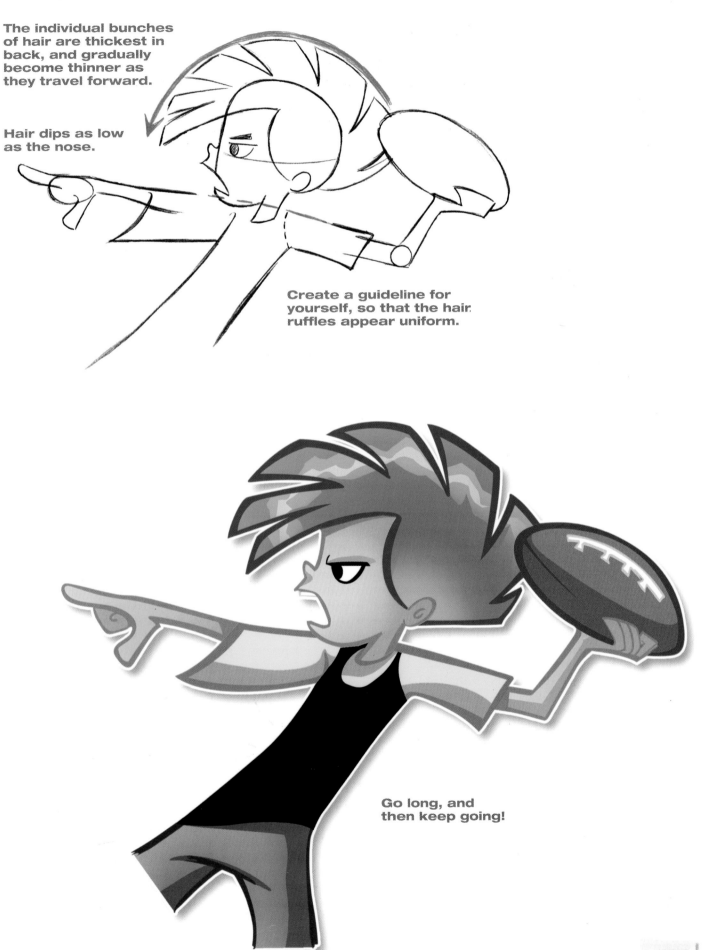

The individual bunches of hair are thickest in back, and gradually become thinner as they travel forward.

Hair dips as low as the nose.

Create a guideline for yourself, so that the hair ruffles appear uniform.

Go long, and then keep going!

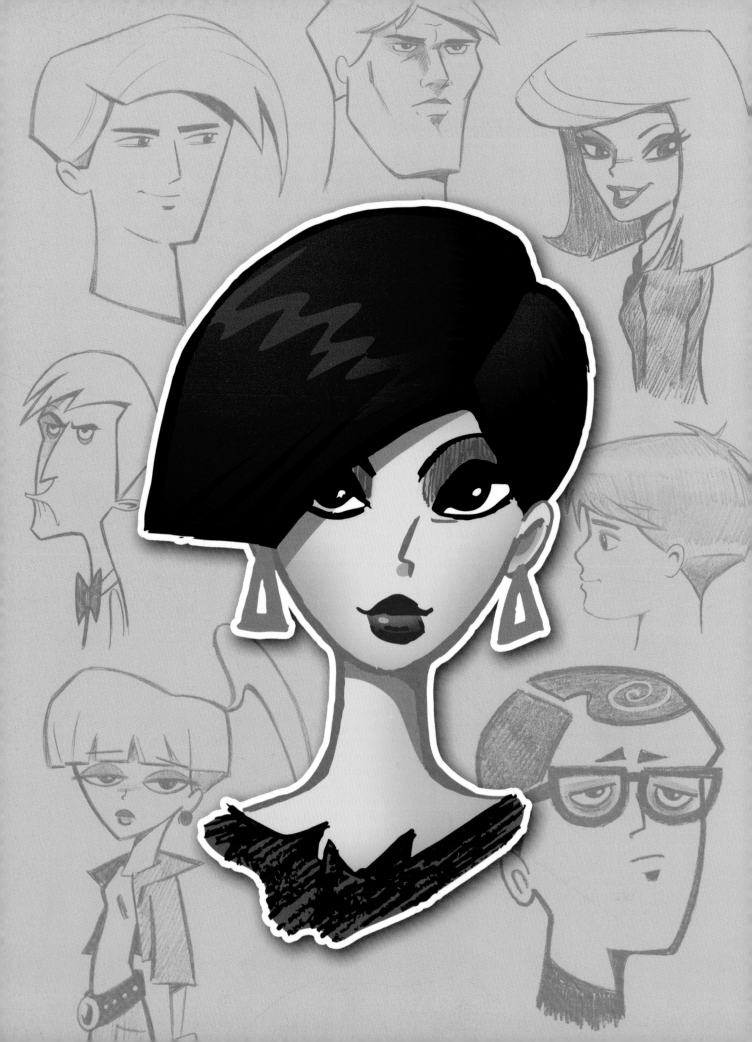

SHADING & HIGHLIGHTS

First, it's important to understand that shading is all about light and shadow. When you talk about "shading," here's what you're really referring to: shadows that are cast in direct response to light.

It isn't essential for all cartoon characters to have shading. Shadows are used to create specific, intended effects. The six basic effects are:

1) Intensity
2) Appearance of roundness and depth
3) Contrast
4) Aesthetics
5) Brilliance or darkness
6) Emotions

Most cartoons are drawn with the assumption that there's a single diffuse light source overhead. The light could be overhead and to the left, or overhead and to the right. The thing to remember is that light causes a shadow to fall in the direction of its beam. For example, if you shine a light on an object from directly above, it will cast a shadow directly below. If you shine a light down across the head, starting from the left, it will cast a shadow to the right.

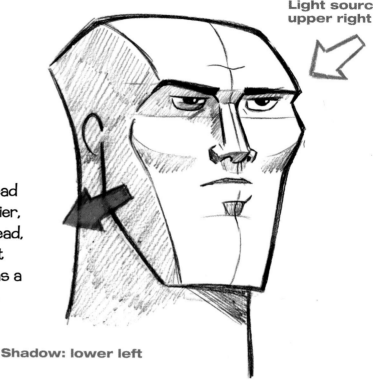

Light source: upper right

Shadow: lower left

PLANES OF THE FACE

Locating where the shadows are on the head can be somewhat mystifying. To make it easier, first sketch a loose, rough diagram of a head, using straight lines to indicate the different planes of the face. By visualizing the face as a solid object defined by planes, you can see the logic of light and shadow.

Minimize shadows to keep the look from getting too realistic.

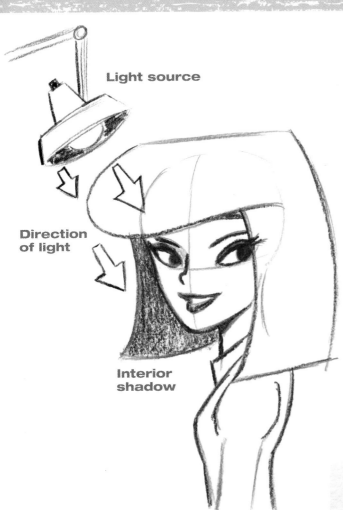

Light source

Direction
of light

Interior
shadow

THE ILLUSION OF DEPTH

Shadows are commonly used to make objects in the foreground appear brighter, and livelier. Artists refer to this effect as causing something to "pop." In this image, the face "pops" due to its contrast against the shaded background of the hair.

Face appears brighter due to contrast with shadow. The layering (front hair, face, back hair) conveys a sense of depth.

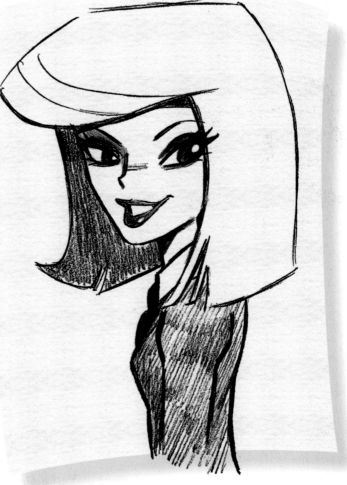

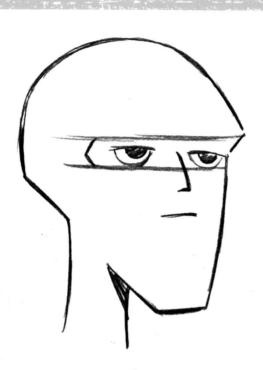

Eye Bar: a horizontal corridor where the eyes go (which is also a depression in the skull).

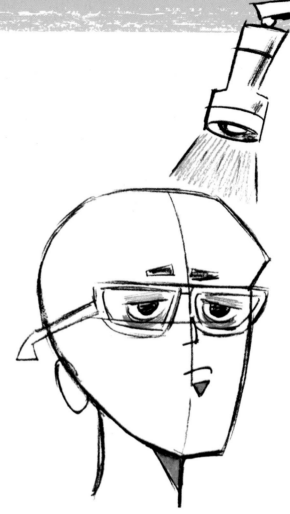

Shadow from overhead light can be cast on the upper eyelid, bottom eyelid, or both.

THE EYE BAR

The eyes are drawn along a thin horizontal corridor that is actually a depression in the surface of the face. Because of this, it is an excellent receptacle for shadows. As light shines down on the head, shadows can form between the eyebrows and upper eyelids, as well as between the bottom eyelids and cheekbone.

If you want to make the character look truly world-weary, add shadows above and below the eyes.

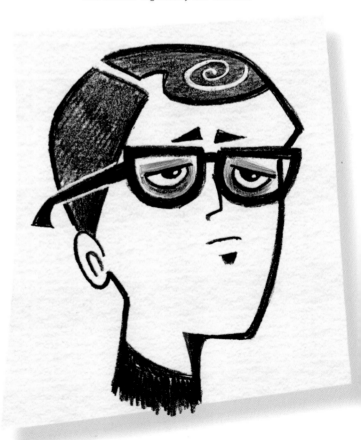

The eyeglasses frame out the shadows around his eyes.

USING SHADOWS AS ACCENTS

Now that we know where the shadows naturally fall on the face, we can pick and choose which areas to focus on to increase the "character appeal." Some shadow effects typically add glamour, while others underscore villainy. But too many shadows can cause a cartoon to appear too serious. How do we avoid a dreary image? By apportioning the emphasis. Some shadows are primary, while others are only minor.

GLAMOROUS CHARACTER TYPE

This character has all of the components of glamour: a chic haircut, dramatic eyes and lashes, and a pouty mouth. The last step is some shadow effects.

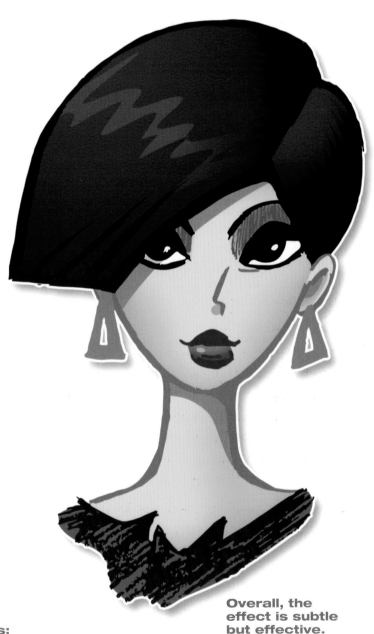

Overall, the effect is subtle but effective.

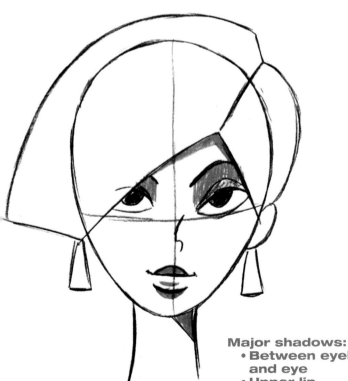

Major shadows:
 • Between eyebrow and eye
 • Upper lip
Minor shadows:
 • Along bottom lip
 • Under bottom lip
 • Neck
 • Forehead

TREACHEROUS CHARACTER TYPE

Is this guy a nasty waiter? A college professor gone bad? An evil inventor? Let your imagination decide.

Major shadow:
• Sallow eyes
Minor shadows:
• Forehead
• Interior of ear

The shading impact is more dramatic, and lets us know that this guy is up to something.

MORE PENCIL SHADING TECHNIQUES

The following shading techniques are useful in softening the look of a character. Cartoons are bold, graphic designs. Adding too much shading can make a cartoon appear overworked. A little goes a long way. Heavy shadows are more typical of comic book characters than they are of cartoons.

HIGHLIGHTS

Add highlights to the hair by creating a "shine." The shine appears as an unshaded patch of hair along the top of the head, in response to overhead lighting.

Note the stretch of darker shadow behind and below the ear.

SOFT SHADOWS

Softer shadows create an appealing look.

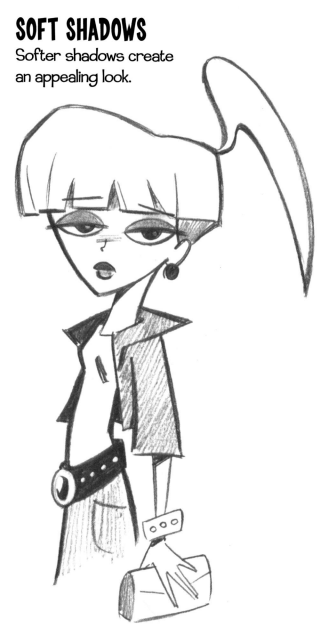

Try these subtle tricks: shadows on the eyelids and upper lip, between ruffles of hair, and behind the ears.

125

LINE THICKNESS

Why is "Line Thickness" in a section about shading? The thickness of a line suggests light and shadow. Thinner lines generally reflect bright lighting conditions, while thicker lines connote a darker environment.

But there's more to it than that. Varying the thickness of a line also creates pace and rhythm. As the eye follows the outline, it moves rapidly along the thinner lines, and slows down along the thicker ones, causing the viewer to linger on the image.

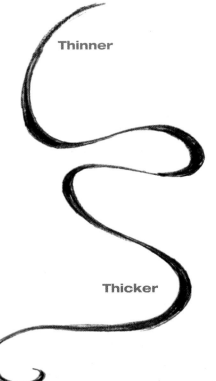

Thinner

Thicker

LINES: NORMAL PERSON VS. CARTOONIST

This is how a civilian draws a line. The in-and-out squiggles are all the same size. It's a nice squiggle, but that's all it is.

In a cartoonist's line, the squiggles are uneven in size, and compressed where they pinch together. But it's in the line thickness where the biggest change takes place. The lines are thickest around the curves and thinner when they straighten out, giving the image pacing.

LINE VARIATION OR "FLOW"

Varying the line thickness gives an image an appealing look. And because it's a subtle technique, you can use it frequently without its becoming tiresome. It creates a dynamic effect, whereas the same size line throughout can get monotonous.

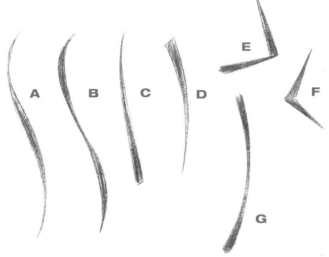

LINE TYPES:
A) Thick in the middle
B) Thick in the curves
C) Bottom heavy
D) Top heavy
E) Thick & thin where the lines meet
F) Thick & thick where the lines meet
G) Top & bottom heavy

Here's a character with a considerable amount of line variation:

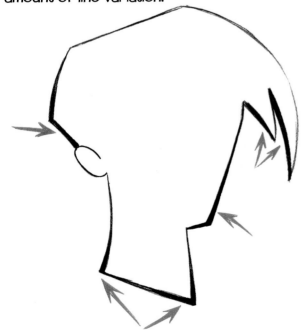

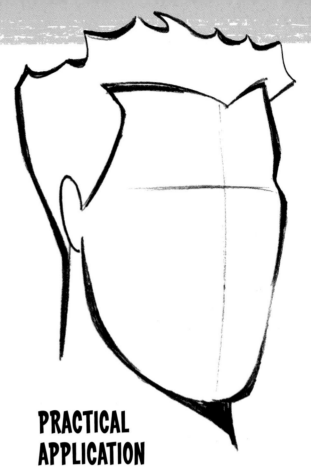

PRACTICAL APPLICATION

When we apply these principles to the outline of the head, the image becomes livelier and more interesting.

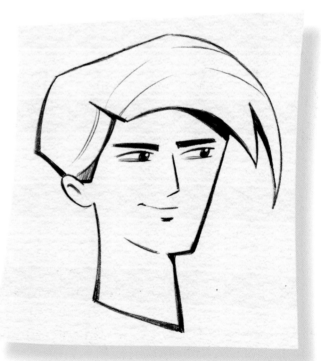

When you pair line variation with shading, you bring a character to life.

This is the chapter you've been waiting for. The piece of resistance. The magnum opossum. Here's where you get to practice your skills by drawing a variety of original, appealing characters. It's a combination of fun and practice. Remember to follow the process outlined in previous chapters: start with the basic head construction, draw in memorable features, adjust or exaggerate the expressions as desired, then work on a hairstyle.

Now for the drawing exercises. First, grab a pencil in each hand. Raise and lower them over your head. One and two and three and four and feel-the-burn. Okay, I think we're warmed up now. Let's get started.

STRAIGHT LINES & ANGLES

There are hardly any curves in the outline of this character's head. It's a series of straight lines and hard angles. Why do you often see hard angles on physically intimidating character types like him? A block-shaped head appears hard, while a round head appears soft. A protruding cheekbone has been eliminated from the face, in order to give the character a streamlined, stylish look.

Note the asymmetry of the thick neck: Only one side slopes; the other is straight (vertical).

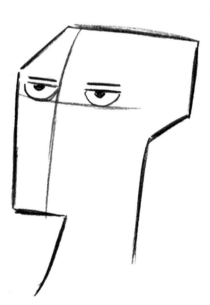

Place the Eye Line high on the head.

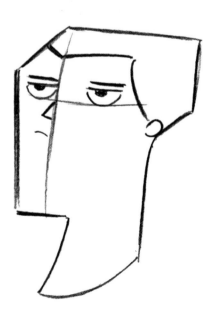

Don't soften the outline of the hair.

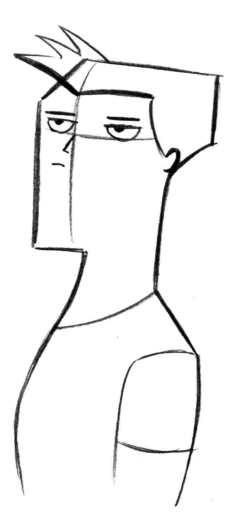

Half-shut eyes work
well to show a
character thinking.

The short mouth, which has
been pushed to the front of
the face, gives him a funny,
cynical look.

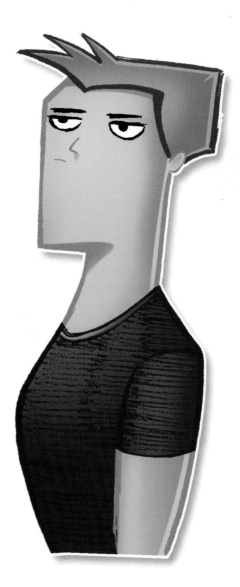

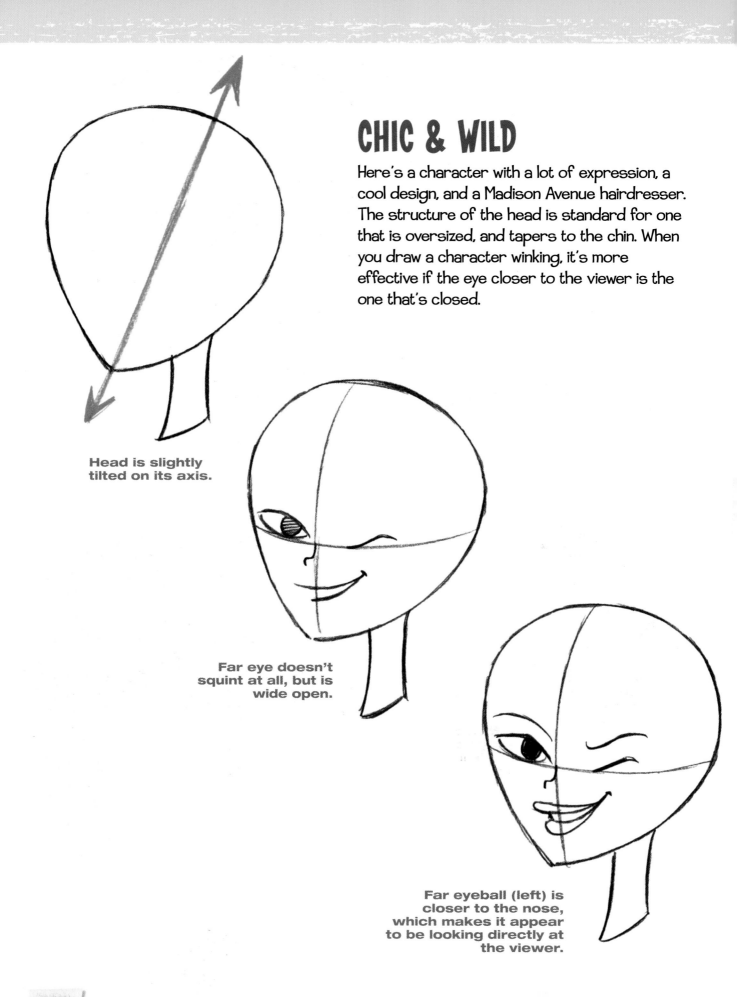

CHIC & WILD

Here's a character with a lot of expression, a cool design, and a Madison Avenue hairdresser. The structure of the head is standard for one that is oversized, and tapers to the chin. When you draw a character winking, it's more effective if the eye closer to the viewer is the one that's closed.

Head is slightly tilted on its axis.

Far eye doesn't squint at all, but is wide open.

Far eyeball (left) is closer to the nose, which makes it appear to be looking directly at the viewer.

Remember "line thickness"? A heavier line is used for the outline of the head, and a thinner line for the features inside.

Note the different eyebrow shapes: the brow nearest to the viewer is almost in an angry position.

Make sure the hair falls over the eyes.

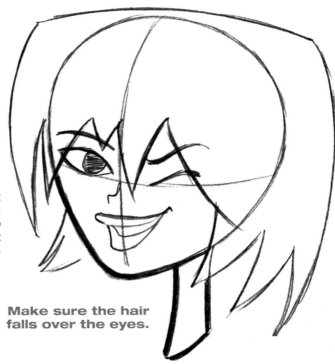

Note the "mascara" (darker line work) added to the eyelashes.

Ruffles of hair give a carefree look.

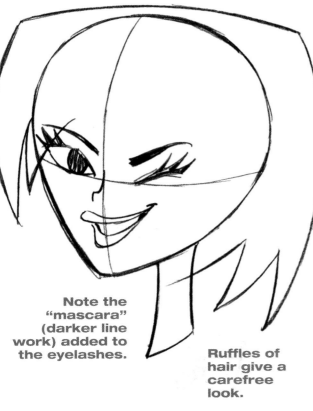

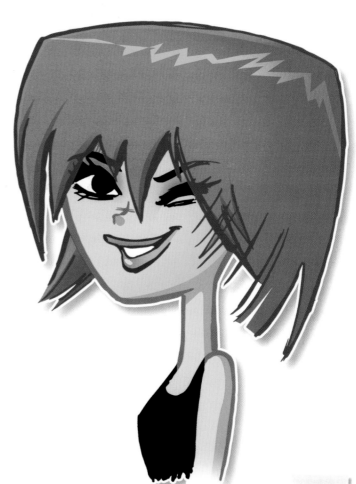

133

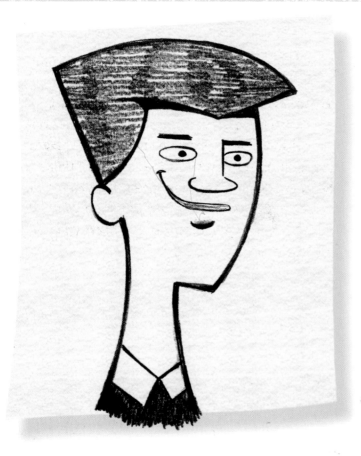

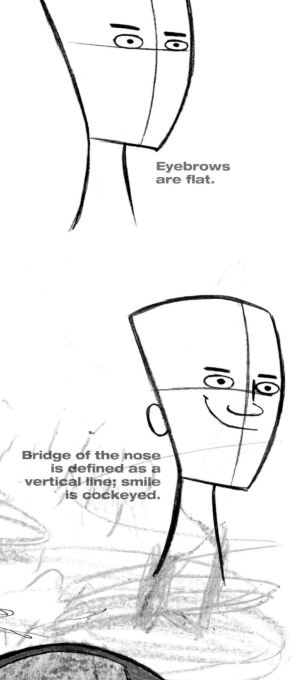

Eyebrows are flat.

Bridge of the nose is defined as a vertical line; smile is cockeyed.

FUNNY STUDENT

This character is totally captivated by something. Given his age and gender, it's either a sports car or food. To make this mesmerized look work, everything is frozen in an extreme, alert position. Wide eyes. Wide grin. And the neck is elongated. A note about the shape of the head: the chin is large, but since it is recessed, it doesn't make the character look like a tough guy.

Back of the head is flattened out for a vertical head shape.

Notice how close to the head the top of the hair is drawn.

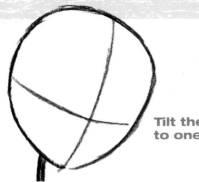

Tilt the head to one side.

FLIRTATIOUS SMILE

Remember how we established, earlier, that female eyes are most appealing when you show a lot of the whites of the eyes? We've created that look here by drawing her eyes darting into the corners. This makes a great addition to her impish grin. Extend the eyelids beyond the eyeballs, in the direction that the character is looking, to create eyelashes.

Extend eyelashes in the direction she's looking.

Eye shadow gives contrast to the whites of the eyes.

Leave the chin pointed.

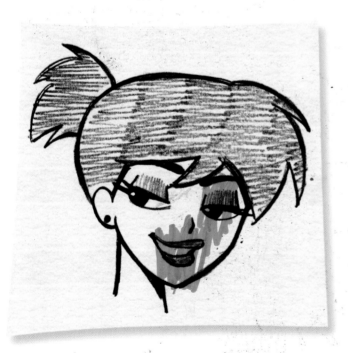

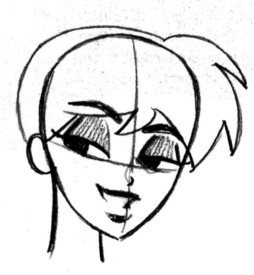

Make sure there's ample room between the eyebrows and eyes, so that you can create large, shaded upper eyelids.

TYPICAL BOY

Everyone loves a boy who is a smart-aleck. This is a popular type among animation fans, because he makes things happen in a story. The smart-aleck is often intelligent, but in an unconventional way. He may not know the square root of pi, but he's figured out the password to the school's grading system!

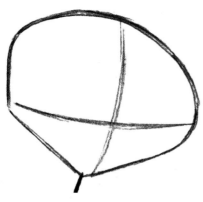

Front of the face is drawn with a huge curve that billows outward.

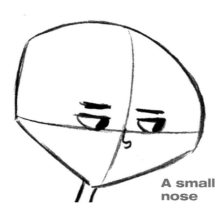

A small nose

The face is actually wider than it is tall!

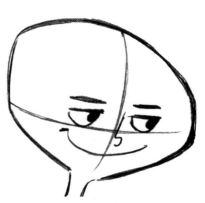

Straighten the back of the head by drawing a vertical line.

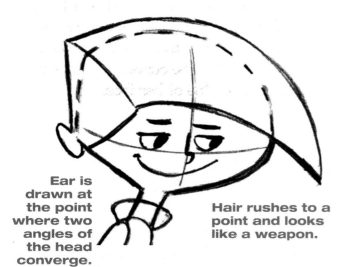

Ear is drawn at the point where two angles of the head converge.

Hair rushes to a point and looks like a weapon.

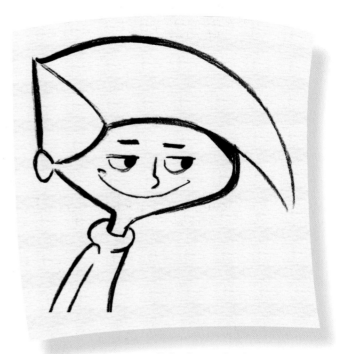

Impossibly long hair on a young boy looks funny.

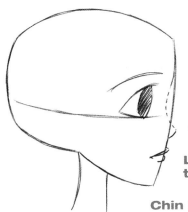

Indent a gently curving bridge of the nose.

Tip of the nose flips up.

Lips protrude from the outline.

Chin is slightly recessed.

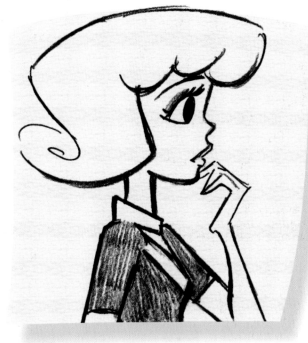

Bring the hair forward, off the forehead.

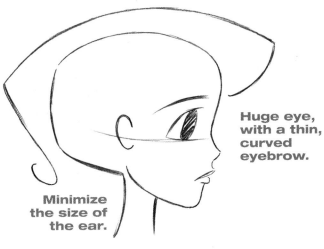

Huge eye, with a thin, curved eyebrow.

Minimize the size of the ear.

PRETTY YOUNG ADULT

Sometimes a character looks simple, but is challenging. Profiles aren't generally subtle, therefore, this character needs a number of gentle curves to create the attractive outline of her face.

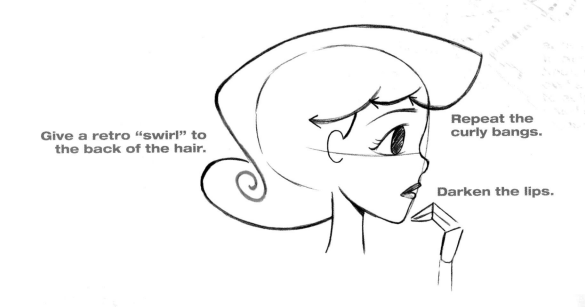

Give a retro "swirl" to the back of the hair.

Repeat the curly bangs.

Darken the lips.

The Eye Line goes where there's a natural break in the shape—just below the brow.

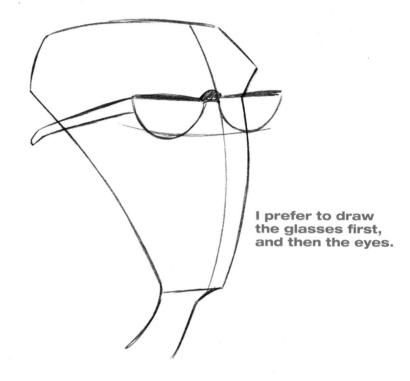

I prefer to draw the glasses first, and then the eyes.

6TH-GRADE ENGLISH TEACHER

"No recess for you!" Caught again drawing during the class lecture. I hated it when Mr. Fartnip used to yell that at me. Over and over again. Day after day. Year after year. I wasn't a bad kid. I tried to spread happiness and laughter wherever I went. And that included English class. It just so happened that Mr. Fartnip did not have a well-developed sense of humor, and even less of an appreciation of caricatures.

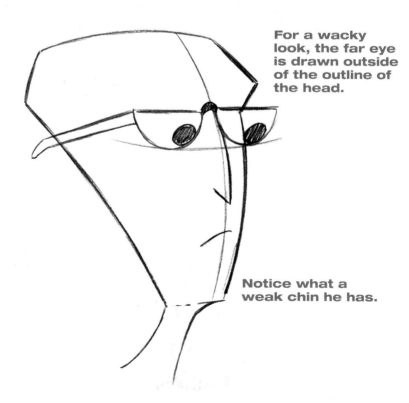

For a wacky look, the far eye is drawn outside of the outline of the head.

Notice what a weak chin he has.

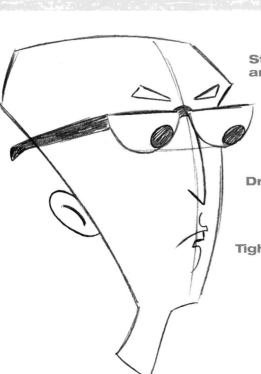

Stylize the eyebrows so they are shaped like little triangles.

Droopy, pointed nose.

Tightly pursed lips.

Hair extends up and leans forward.

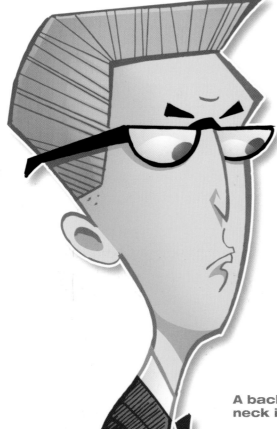

A backward curve of the neck indicates bad posture.

CHARACTER FINDER

Did a particular character-or two or four-tickle your funny bone?
Here's a quick, visual guide to the step-by-step tutorials in this book.

BOYS

Anxious Boy p.17

Sideways Glance
p.20

Devious Boy p.22

Cute Kid p.31

Goofy Ears p.55

Long Neck p.57

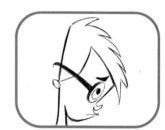
Kid in Trouble p.59

Young Teen p.76

Exaggerated
Overbite p.83

Exaggerated
Forehead p.85

Looking Up p.95

Over-the-Forehead
Hair p.109

Flipped-Back Hair
p.109

Very Full Hair p.111

Big Hair p.111

Wild Hair p.115

Punk Hair p.117

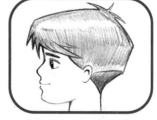
Highlighted Hair
p.125

Typical Boy p.137

GIRLS

Shifty Eyes p.17

Laughing Girl p.25

Elf Girl p.33

Headband Girl p.36

Flat Ears p.50

Staring Girl p.62

Overwhelmed
Student p.79

MEN

Grinning Guy p.12

Gruff Guy p.12

Anxious Guy p.17

Staring Man p.21

Wacky Guy p.23

Wincing Man p.24

Office Manager p.30

Wide Nose p.34

Rugged Nose p.36

Viking p.41

Businessman p.42

Bottom Teeth p.49

Tilted Ears p.51

Glum Guy p.53

American Middle-
Aged Man p.69

Bald Guy p.72

Office Guy p.75

Dopey Dad p.77

Criminal p.87

Toothy Guy p.93

Puzzled Punk p.94

Surprised Guy p.95

Flopped Hair p.108

Hair in Front p.110

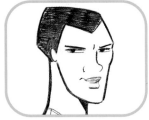

Short Hair p.110

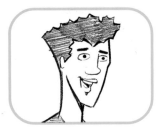

Flat-Top Hair p.114

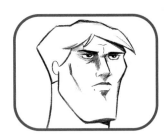

Angular Face p.120

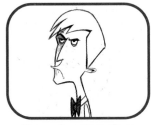

**Treacherous Guy
p.124**

Pointy Hair p.127

Straight Lines p.131

**English Teacher
p.139**

WOMEN

Large Eyes p.15

Sultry Eyes p.26

Arched Brows p.29

Chatty Woman p.43

Smiling Lady p.47

Curvy-Lip Lady p.48

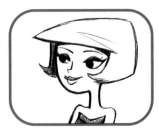

**Glamour Character
p.65**

Cool Chic p.67

Sharp Lady p.73

Pretty Woman p.78

**Exaggerated Head
p.82**

**Exaggerated Taper
p.84**

Elongated Face p.91

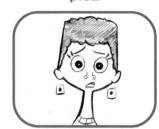

Stern Profile p.94

Stretched Neck p.96

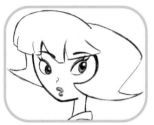

Retro Hair p.101

Trendy Hair p.101

**Straight Bangs
p.102**

Swept Bangs p.103

Angled Cut p.103

**Casual Hairstyle
p.104**

**Ponytail with Attitude
p.105**

Wide-Top Hair p.106

**Egyptian Queen
p.106**

Evil Neighbor p.107

Stylish Hair p.113

Deep Shadows p.121

**Glamour Shadows
p.123**

Chic & Wild p.133

**Flirtatious Smile
p.135**

**Pretty Young Adult
p.137**

INDEX